A
STRANGER'S
POSE

Emmanuel Iduma

With a foreword by Teju Cole

Abuja – London

First published in 2018 by Cassava Republic Press

First reprint, 2021

Abuja – London

A CIP catalogue record for this book is available from the National Library of Nigeria and British Library.

ISBN: 978-1-911115-49-6
eISBN: 978-1-911115-50-2

Designed and typeset by Allan Castillo Rivas.
Cover Design by Maia Faddoul.
Cover image by Dawit L. Petros.

Distributed in Nigeria by Yellow Danfo.
Distributed in the UK by Central Books Ltd.
Distributed in the US by Consortium Books.

Printed and bound in Great Britain by Bell & Bain Ltd., Glasgow

Stay up to date with the latest books, special offers and exclusive content with our monthly newsletter.
Sign up on our website:
www.cassavarepublic.biz

Twitter: @cassavarepublic
Instagram: @cassavarepublicpress
Facebook: facebook.com/CassavaRepublic
Hashtag: #StrangersPose #ReadCassava

Foreword

By Teju Cole

A ballad is a form of dream. Like any good narrative form, it contains surprises, but a ballad delivers its surprises gently. Miles Davis had a clear favourite among the pianists of his generation, Ahmad Jamal, who believed that the most difficult thing for a jazz musician to do was to play ballads well. Jamal's gift was a special ability to play the spaces as well as other people played the notes. He idolised a sax player of a generation earlier, Ben Webster. Jamal liked to tell a story about Webster's approach to ballads. Once, while playing a ballad with full and soulful commitment, Webster suddenly stopped. "Why did you stop?" Jamal asked him. "I forgot the lyrics!" was Webster's reply.

Imagine a ballad, then, in which the text unfolds like a melody, one in which— unexpectedly, but in the most artful way— photographs appear like harmonies. Imagine such a ballad serving as the atlas of a borderless world, traced out but not painted. Delicate. It is a ballad in which the body remembers gestures forgotten by the mind. Sensate. A body that wanders without fear of getting lost.

Imagine a song in which a doctor's fingers are "memories of the pulses of everyone," a song in which strangers smile at each other in pre-linguistic compromise. Imagine the enchantment of unerring musicality, of a love story inside a love story, of a care for those things that are seen by all but noted only by a stranger. Imagine a ballad with travelling companions who flit in and out like instrumental voices, so that you don't know if you are

hearing something improvised or through-composed, so that the distinction between the two becomes irrelevant, a song that magically doubles as a melancholy history of West African photography, but without the starchiness of undigested scholarship. Softness, sensibility, gentle surprises. Could there be such a ballad, and one that at the same time demolishes frontiers and security posts, that is aflame with anger on behalf of the dispossessed, and that rescues something of the men and women crushed underneath our current societal arrangements?

Dream of a song such as this: a billowing daraa that fills with story and sails through page after page, a song of encounters, of the bonds of family, and the inescapability, finally, of the vulnerable self. Imagine a ballad deeper than any fiction, more exciting than any reportage, a testament to life even while life is being lived. In this quintessence of many journeys, immense distance is folded, like a rope, into patient sentences and images glow with the radioactivity of communal memory. The singer sings of a tribe getting larger and larger until it includes everyone, until the entire world is intimate.

Imagine a ballad in which "night after night, hope is gathered in the sacks of the unknown," a ballad of African occasions seen by a clear-eyed traveller. The song of which I speak is one in which the disregarded sidestep self-regard and enter a deeper self-witnessing. Imagine such a ballad in which there is no need to separate dreams from the things which one experiences in a waking state.

Ballads are a simple form, concerned with foundational human emotions. What Ahmad Jamal said about them was that "it takes years of living" to play them well. I dream about a book like a great ballad: full of years of living,

which is another way of saying full of wisdom. The author doesn't have to be old. The book doesn't have to be big—better, in fact, that it be succinct, every page necessary, no wasteful flourishes. Dream of a perfect book, a ballad with all the lyrics remembered. The sleeper wakes from dreams. That book is in your hands.

Teju Cole
Brooklyn, February 2018

1

On impulse, before anything else, in a white E350 Ford van I drive into Mauritania at sunset. I see a duneland, and then houses built as if to imitate matchboxes. Today Eid ul-Fitr begins. Men are walking back from mosques, women and children trailing them, sure-footed and celebratory. I see all this with my nose pressed to the window. The men wear long, loose-fitting garments, mostly white, sometimes light blue. I watch them from behind, and think of the word *swashbuckle*. I am moved by these swaggering bodies, dressed in their finest, walking to houses that look only seven feet high. I envy the ardour in their gait, a lack of hurry, as if by walking they possess a piece of the earth.

I want to be these men.

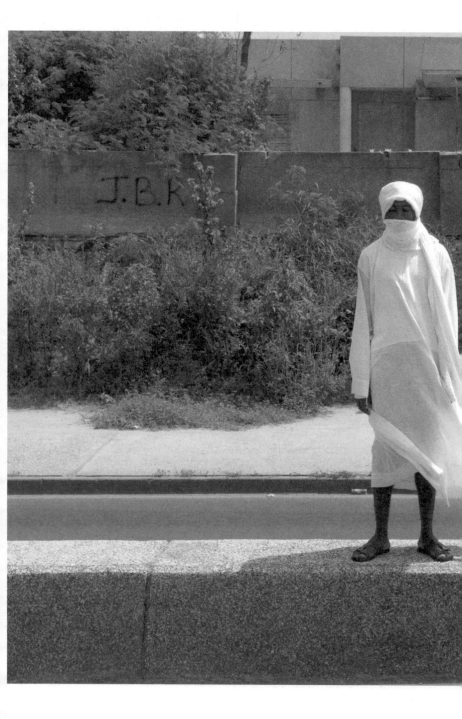

2

Awake or in a dream, faces and images and gestures from my travels return to me in great detail. Sometimes it is the wind, sputtering against the window of the car I am in. Or an underfed dog, rummaging through rubbish for a glinting bone. Or a boat unmanned in the middle of a river, seen from afar.

I began to exchange emails with a relative who requested anonymity. My first email was a list of all the towns I had slept in during my travels, at least for a night. Towns in which I turned in my sleep unsure of where I was, whether I was bathed in sweat or in tears, or if I lay beside a lover or a travel companion. I hoped, I wrote, that the cities appeared untethered to their countries— an atlas of a borderless world. In the first response I received, I was urged to recount stories of strange sightings, emotions, and encounters, remembered or imagined.

Take me with you on your journeys, my relative replied. Let me go in your place.

3

Once, I arrived at a bus station in Lome ten minutes past departure time. The buses headed for Accra left every two hours. An agent advised me to purchase a new ticket. An arts centre had taken great pains to create and maintain a schedule for my West African book tour. I spoke little French and had no working phone to explain the predicament to my hosts. In my attempt to salvage the situation, I walked up to a few strangers in the terminus. I asked if I could borrow their phones, and for a few seconds each would listen, confused at the meaning of my French, which was little more than gestures and babbles. Then, when understanding came, they would shake their head in the negative, making one excuse or the other.

The physical details of that Lome terminus skip my mind, but I do not forget the heads of potential benefactors shaking in the negative. Hadn't I deserved this turn of events? That morning, before taking a shower, I sought familiarity with the streets around my hotel. I took photographs of walls, gates, and passageways, passing time. Facing one of those walls, I attempted to make sense of the notice: *vendre*, a word for sale; *ne pas*, a sense of disallowance. Beyond the wall, life seemed unrestrained, yet the inscription seemed to warn against crossing over. If the people moving on the other side were tall enough I saw their heads, nodding in conversation, turning in dissent, steadied in motion.

5

For days, depending on the availability of Mamadou, I had no guide in Dakar. It amuses me, now that I remember, how I walked in Point E nervous of what world was possible without English words. My French and Wolof constituted no more than a sentence when combined.

Once, overlooking the sea in Ngor, my eyes followed the path the surfers made as they performed their stunts. I see what rivers— the Nile in its stretch beyond the Mediterranean, the Niger as it joins Timbuktu to Lokoja— teach with their flowing mass. Wave falls on wave, as one dialect inflects on another. All rivers are multilingual.

I was nothing without the translators to whom my questions were entrusted, whether in Bamako, Abidjan, or Casablanca. But, alone, as was often the case, I wondered how to survive without them.

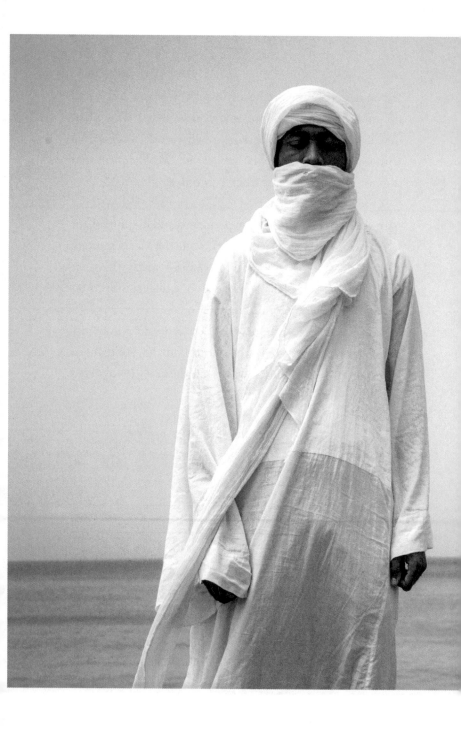

6

I looked at French words to guess their meanings. But there were times I faked understanding. In Rabat, when I went to Pause Gourmet for salad and café au lait, I would say yes to everything, hoping the question posed required a yes or a no. All my yeses were indicative of a larger paranoia, that of being marked as a clueless stranger. *What the hell was a person who didn't speak French or Arabic doing in Morocco?* Sometimes yes would be inappropriate, or insufficient, requiring a modification. The waitress would immediately perceive my limited understanding, and ask for what I wanted in a clearer, drawn-out way. Again, I'd nod, suggesting finality with a smile. That would settle things.

Or when Khadija rang the bell of my apartment. I got dressed and went for the door. She was mopping the floor, this middle-aged woman who began to speak in rapid French when I appeared. I perceived she was talking about her work in the building— *travail, ici*. My nods were tentative, speculative. She didn't seem to mind. She wanted to exchange numbers. If I wanted any help with the apartment I could call her. She left and returned with her number on a small piece of paper, written in blue ink. Also, a small piece of paper for me to write mine. When I gave her my number she asked if it was okay for her to call me. *Oui, oui.*

Or when a man came from the hotel to take me to a new apartment. The agreement was for me to stay in the first apartment until the new one was ready. He came to take my bags, explaining this with limited French. Frustrated by our translation problems, he asked if I spoke Arabic. No. From then on he seemed impatient, and yet subdued— almost rash in the way he suggested what he meant by lifting things

and moving them before attempting to communicate where we were going.

After regular visits to Pizza Zoom for lunch and dinner, it seemed I was marked alien. I perceived— perhaps by dint of exaggerated self-importance— that I was the subject of fleeting discussions in the kitchen. Waitresses and their male colleagues recounted their encounters with me: *He nods to everything, he wouldn't pronounce "brochette" the right way, he always reads an English book.* English is my fate here. The cashier, once when I tried to pay for my meal, switched to English to confirm what I'd had. I responded with relief. *At last.*

I wore my language deficiency like a veneer, like gauze, like stratum. Underneath was tangible communication, out of reach. Yet I did not bemoan this. My deficiency was benign in comparison. For migrants arriving in Morocco from countries south of the Sahara who have to make a living or wait almost interminably for a better life, to acculturate is to survive. Without the knowledge of French or Moroccan Arabic, they face the belligerent wall of inadmissibility, confined to the fringes of their new society.

7

The cost of my travels, if I made a tentative sum, included a precarious love affair in Lagos. I gathered memorabilia in each new city, as if they were placatory bricks to bridge the distance; paid passage from her to me. Those potential keepsakes had the feel of poems written on the spur of sentiment, for immediate effect: petals of a sunflower carved on a wooden brooch; a key ring with the depiction of a local Marabou; baking instructions behind a postcard. On two other postcards, covered in doodles, I wrote the following:

> I practice what kind of shapes I'll make on your body:
> Clusters of circles on the back of your wrists...
> Repeated triangles around your navel...
> Spheres with my lips on the corners of your face, then your mouth...
> A rhombus around the scar on your left arm...
> Numerous inch-wide rectangles from your knee to your hip...
> Squares with curved edges along your torso.
> For the sake of this exercise, I have bought a sketchbook.
> When will I see you again?
> I've made my days into dispatches and unsent letters. I sleep little. I switch beds, and night after night hope is gathered in sacks of the unknown.

8

Once in N'djamena, whilst in a market, I walked with a small camera. In the course of my strolls, I refrained from taking photographs. Sometimes I made exceptions, depending on what was in view. The market in N'djamena was the first place where I saw the head and entrails of a vulture being sold. For voodoo, I was told.

A woman in hijab held a weeping man, patting his head, wiping his face, their legs sprawled on the dusty ground. I approached, uncertain. When I realised I had caught the attention of the woman, who had managed to calm the man a bit, I held up the camera for a shot. The woman's sudden scream jolted the man, and he became inconsolable, again. I grew nervous when I noticed people pointing, encircling me. A policeman appeared— I might have been watched, or, worse, followed. The policeman pointed to the camera. I handed it to him without protest. He led me to a station I hadn't noticed before, about fifty yards behind where the weeping man lay.

I was released six hours later following the intervention of an hotelier I met on my first night in Chad. The photograph had been deleted. I walked back to the market, to make my way out. The woman in hijab still comforted the weeping man, who, in addition to being inconsolable, now threw dust, from time to time, at people walking past.

9

Most mornings in Nouakchott I sit with Lejam to eat. For breakfast we pay a total of 1,000 ouguiya for baguette and egg, juice and butter, café au lait, and water. It takes me ten minutes to walk to the restaurant. For ten minutes I walk with music, SONY earphones around my head, a notebook in my pocket. I walk, wearing the slippers I had bought in Dakar. Sand flies in every direction. Desert sand. Despite its modernisation, writes a visitor, Nouakchott still seems like an encampment of nomads.

Lejam, one of the nine artists I'm travelling with, takes pictures of me. He does this as if he has his finger and eyes on moments of significance— like the photograph he takes in Rosso, the town with a river that separates Senegal from Mauritania, right at the moment we enter the ferry. And it is after one of those breakfasts that I go with him to a visa preparation office, which bore "Formalite Visa— Maroc-Espagne-France" above it. White Mauritanians oversee would-be applicants as they gather required documents. Many of these applicants will fail to get visas. They will risk deportation and the harshness of the sea, and immigration officials armed by the European Union. I do not enter the visa preparation office.

The conversation about preparing documents to apply for a Moroccan visa have been left to E., the director of the organisation undertaking the road trip. He is fluent in French. The trip, expected to last a total of a hundred and fifty days, is a stretch from Lagos to Sarajevo. Mauritania is the last frontier before Morocco, and Morocco is the last frontier before Spain. Six persons in my group require Moroccan visas. In the months before now, E. and I have attempted several applications for the Moroccan visa— in

Abuja, Bamako and Dakar— without success. Each consulate, in turn, referred to an earlier intolerable mistake: we had included "Western Sahara" in our itinerary as an independent country, ignorant of Morocco's claim to control its territory, its people, and its resources.

Now Lejam, who owns a Canadian passport and doesn't need a visa, takes a photograph of me with his phone. I pose beside the office door, my eyes half-opened. But my face, when I consider the photograph later, indicates I am aware of how I position myself. Lejam asks me to stand beside the door after he has seen how E. stands— his stance more or less an indication of tenseness, as if readying to spring back into the office. My pose camouflages this tenseness, even nullifies it. I rest my back on the wall, standing in a way that suggests that if a chair were placed behind me, I would have slouched. I appear carefree, as one deferring worry.

Asked by Lejam to pose beside a tense E., I wonder about how, on certain occasions, in the course of travels in which nothing is certain, to pose for a photograph is to acknowledge the possibility of respite.

E. is a good dancer, so good that when we go to parties people stop to watch him, even making videos with their phones. In Nouakchott, Lejam downloaded a number of Nigerian pop songs from iTunes, and when the day had come to an end, after another unsuccessful visa attempt, he would sometimes play the same songs back to back. E. and I would begin dancing, my moves hoping to imitate his. In that moment, being without a visa becomes a minor, distant worry. The only thing that would matter while we danced, like in the photograph, would be the here and now. How the body dancing, finds reprieve.

10

On the night I arrive in Benin City I sit in a taxi. I am calmed by the driver's chattiness. He describes the city's quarters as we drive along. We are headed towards the G.R.A., and we drive past a hotel. It is lit with a floodlight, famous at night for men looking for sex. In front of the hotel there are taxis waiting. Even with a brief glance at the taxi drivers who loiter to pick up other men, I see that each is prepared for a long stay into the night. Perhaps they arrived early to claim spots. Or, tempted by what their eyes imagine their pockets can afford, they'll make an offer to one of the women.

I do not see any woman waiting to be picked. It might be too early for this. It is only 8.00pm. How interesting, I think later, that there are men around the hotel for whom, like sex workers, this isn't merely a question of pleasure. For both, the body is put to relentless work.

I ask the taxi driver for his number. Responding to impulse, I want him to take me around the city at daylight. He has lived all his life in Benin. Men like him carry routes within themselves. As though with each shortcut he takes, he sketches a less officious map of the city. I want to assimilate, in the shortest time possible, the knowledge of all the routes he favours, the city mapped by his hand.

He recites his number to me, confirming he could drive me at daylight. But the next day, and the day after that, I forget to call him.

11

Photography is like hunting, Malick Sidibé says.

When we visit, he is wearing a fitted white jalabiya, sitting outside a house, part of a cluster of buildings, each coated in reddish brown. His eyesight is failing. I cover his hands in mine, in greeting. A woman and a man prepare him for the public eye. The woman brings a towel and spreads it across his lap; the man brings sunglasses. I am overwhelmed. I feel as though his entire oeuvre is compressed into a moment in time, this.

Before we talk, we are shown into a room with his negatives, old equipment, and stacks of photo albums. Things are in bad shape, worn by time, layered with dust. Some of the dust will leave with us. There's a bed in the room. Perhaps he lies here when exhausted, to remember photographs without looking at them.

We sit and he talks. Igo Diarra of Medina Gallery, our host and guide, translates the conversation from French. Sidibé tells us he started drawing in 1945, using charcoal. He drew because he wanted to imitate natural forms.

Because he has never used a digital camera, he conceives photography as an act of deliberation. He learnt what he knew about photography by observing closely. To observe is to be alert, to find precision, balance.

Now that he is losing his eyesight, Sidibé cannot continue working. I suppose that not even impaired eyesight can take away his ability to perceive images. Every nerve in his body seems to respond to light and movement. Time has slowed him down, but he is here, still.

Sidibé asks the young man to bring us a photograph from 1963. It is his favourite and known around the world

as one of his most iconic: a young man and woman dancing during a Christmas party. It had to be about dancing, I think, remembering something about dance being the fulcrum of desire. Photography is a charismatic medium. Sometimes it takes five decades for a photograph to unravel itself.

In the photograph, the girl was barefoot, the boy was wearing a suit and tie, and their knees could touch, it seemed, at any minute. What interested me were the smiles on their faces, and the girl's arm, which held her gown in place; a dance of such zest threatened to reveal her underwear. I wonder what he thought when he took that photograph. It strikes me that the pose is similar to that of Amiri Baraka dancing with Maya Angelou in Harlem, in the 1991 photograph by Chester Higgins Jr.

People come to him from around the world, he says. He's responding to a question about his children. The question has been lost in translation. Yet the image is perfect: a man whose way of seeing has stirred the hearts of thousands, indisputable as father.

When asked about photography going digital, the democratisation of the photo-making process, he says, It's okay sometimes. Everyone has a right to have their image taken, but people can also transform the image into something else. He seems ambivalent about this. I guess he's still fascinated with the old ways of working. He tried to catch up with digital cameras, he says, but it just seemed overwhelming.

He jokes that these days you don't need your eyes to make photographs, you just shoot. We laugh.

The other time we laugh is when he talks about being in Mauritania. It had been difficult to put his subjects in good positions because men didn't want him to touch their

wives. A photographer is like a doctor, he tells us. If you don't touch, you do nothing.

He adds that he had been a composer of images, favouring the studio over the street. The contours of his subjects' bodies form poses like in a drawing, line added to line.

Someone asks if he has any questions for us. No. Any advice? None, he says, but it is good to travel, you understand many things.

I am very happy, he says at the end.

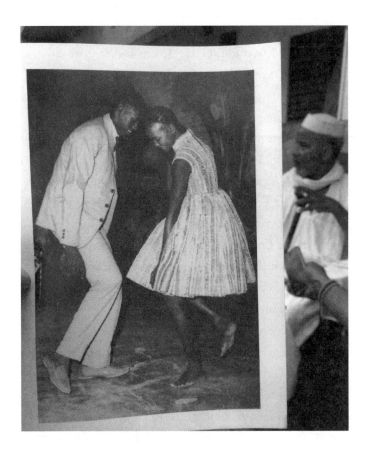

12

While Sidibé spoke I mulled over a sentence with which he opened the conversation: Photography is like hunting.

Unknown to a sprinting deer, the hunter's hand was steadied on the trigger, and combining precision with an element of indeterminacy, he shot. The animal was shot in motion, its movement truncated.

I am reminded of an encounter with Idrissa. The meeting took place in Diéma, a thoroughfare town on the road out of Mali, 1,000 kilometres before Dakar. Idrissa— he seemed in his early twenties— managed a station where I stopped to buy petrol. His voice was full of laughter and great knowledge. At first he spoke French to me, then he saw the plate number of my van.

Oh, he said, I have been to Nigeria.

In Lagos, he sold ice cream, hawked on the streets. He chose Nigeria because English was spoken everywhere— you didn't have to go too far, or even to school, he said, people spoke English on the street. I followed lorries, he continued, which could mean he had to squat on the back of trucks, a co-passenger with cows being transported for sale and slaughter.

Then he confirmed he had been elsewhere. After six months in Nigeria, he spent eighteen months in Cameroon, and two in Gabon. Diéma was his birthplace, where his family lived, but if he had the opportunity, and once he had saved enough money, he'd return to Nigeria.

His life, as he narrated it, consisted of many truncated movements: the pause, for instance, between saving money, and buying his way out of Diéma. His time in Diéma was transitory, a placeholder for subsequent movement. Idrissa did

not describe his movement in linear terms, but as a circular journey. He spent time in Cameroon and Gabon, returned to his hometown, but kept a final destination in view.

The route I travelled— across Mali, Senegal, then Mauritania— was punctured with stories of women, men, and children transiting towards Europe. Often they met bureaucratic brick walls, stiff immigration policies imposed by the governments of North African countries in collaboration with the European Union (Mauritania is 800 kilometres south of the Spanish Canary Islands). And meeting these brick walls, they stopped to regroup. They found new ways to outmanoeuvre the omnipresence of the Spanish civil guard, to keep moving towards an imagined better life.

13

In Abidjan, I visited an old sculptor who lived with the debris of the dead: installed as dolls and skulls, propped by decaying wood, obscured by layers of canopying leaves in an untended garden, glued to canvases. The dolls, when I approached them, seemed statuesque, graceful. Or, when I brushed away a leaf, the skulls laughed and cheered while I stood, enchanted. Left in the open, beaten by the rain and discoloured by the sun, they possessed the diaphanous quality I associate with the netherworld. So weightless they could be here one moment and gone the next.

He was revered as an artist of rare deftness; his ability to create order out of chunks of etcetera.

My fellow travellers took photographs. It was evening. Someone used a flash. The light brightened the yard and new skulls came into view, as if waking the dead by illumining their frontal bone.

For several months after I visited the old sculptor, I dreamt of a recurring scene. It is dark and I walk with a camera in an atelier. Only dolls and mannequins, propped on a tree or reclining on a chair or laid on a stool, are present. They are uncertain about my presence. Are we safe, will he harm us, are we to be displaced? I am uncertain about my intentions; provocateur or friend, flâneur or voyeur. It is this uncertainty that made me bring the camera. It is dark and I take photographs with a flash. I know, for a reason I do not recall, that light must not fall on the dolls. They are owl-like, reclusive things. And it is a matter of their continued survival in the courtyard. Yet I do what I have been warned against. In the next scene of the dream there is a large protest by dolls standing on the stairs of the museum.

And in the final scene I am whimpering in a corner, facing a wall of defaced paintings, shamed. I put the dream away as confounding. Until someone— who knows who— will relay its meaning.

14

During the course of my first road trip across Cameroon, the passenger bus I had boarded from Douala in the south to Yaounde in the north was flagged down at a checkpoint manned by Gendarmes. The driver, as the officials alleged, had certain documents missing, and so was liable for a fine. I stood with pocketed hands beside other passengers, amused at the blatant way the driver and a senior Gendarme negotiated a bribe. You, the officer pointed at me, come here! I had been smiling. The driver, as though he knew what was next, said, Don't put us in more trouble! When I arrived in front of the officer, he instructed me to follow him to the station across the road. I followed with feigned ease, conscious of eyes that trailed me.

The station was a wooden shed, upheld by bamboo sticks, canopied with tarpaulin. Once inside, I saw a table and a chair and, a few metres away, a pile of small stones spread on the floor. He asked me to kneel on the stones. I could tell from his breath that he was drunk. I knelt. Once I did this, he began to deride me. An important-looking man like you, he said, see how I have made you nothing!

15

The image of a limping man flashed through my mind.

He was Serge, the caretaker of the motel I stayed at in Abidjan. I could never tell when he came and went, if he came and went. One afternoon I climbed down the stairs to dispose shredded paper, walking around the motel's small compound looking for a wastebasket. Pardon, monsieur, he said, and took the paper from my hand. Then he limped away.

The manageress mistreated him. She scolded him at every opportunity. He is bad omen for my business, she said to me. He had come from Ferkessédougou, a town in northern Côte d'Ivoire. Anyone from there was as clueless as sheep.

Every night she would ask me for a recap of the day's events. I would sieve through my encounters, making an effort to speak well of her city, for which she had nothing but praise. One of those nights, she talked about Serge as a misfit she must dispose of. You know, she said, people come here for pleasure. Yes, I said, joking that I must be a bad customer since I didn't respond to the occasional taps on my door. Well, that's okay, she said, but you know that Serge once opened a room during the course of, erm, business. He apologised, but proceeded to sweep the floor. My girl and my customer, who were at the height of foreplay, had never seen something like that. So stunned were they that they left him do the sweeping.

Sometimes I would see Serge and the manageress having a chat in the compound. He would be washing a pile of clothes by hand, with a large bowl beside him, and she would sit on a stool close to where he sat on the floor, resting his broken right foot. It would unnerve me when she laughed at something he said, since I could not tell if her laughter

was sincere or in mockery. Their conversation would be in the conspiratorial manner of gossiping friends. Hours later, she would begin berating him again.

Early one morning, policemen came for Serge. Before they pulled him away, one of them took a photograph with a tiny Kodak. This is evidence that you were alive when we took you, he said. After we're done, no one will recognise you.

On the morning of my departure, the manageress gave me the resulting photograph. They sent it to her, she alleged, as the only guardian of his they knew. You must keep it, she said to me, because I don't want to keep seeing his face in my dreams.

When I remembered Serge and his inexplicable arrest a few years later, I searched through my things for the photograph. By now I had a stack of portraits, progenies of many short-lived encounters on the road. Which face belonged to Serge? Only one portrait seemed to be his, but behind it I had written "A Nigerian in Libreville."

16

Once, also, on the road that leads to the centre of Nouakchott, while I attempt to cross over to the sidewalk, a group of young men in a car stop beside me. Their Arabic is animated, and noticing my glare of miscomprehension, one points at my camera. I understand their request. I look above them. I see the portrait of the current president looming overhead. To have their picture taken, they would have to stand with their backs to the billboard. For a moment, I entertain the thought that they are asking for a photograph to demonstrate allegiance to their president. Once the photograph is taken, they return to their car. I cannot remember if afterwards they ask for the photograph to be sent to them through Facebook, but they don't ask to see what it looks like on the digital camera. Why so? Why did it matter to them that a stranger, in a moment of fleeting encounter, took their photograph?

At the moment of posing, they make themselves into the people they want to be. They ask to be photographed as if, through a camera and a willing photographer, they can represent themselves as they see fit. And in being photographed, in the creation of a document of their pose, they affirm their place in the city. Left with photographs I had no need for, except perhaps to serve as a reminder of their confidence, they indicate how, were I less restless, I might claim a place.

Their fathers and grandfathers before them, as they settled, pushed the black Africans of the region further and further south, towards the Senegal River. In the process, tens of thousands of African men, women, and children were captured and taken into slavery in encampments further North. The enslavement of their progenies continued.

17

I recall the day I borrowed the daraa.

Salih, my white-skinned Mauritanian friend, is introduced to me a day after my arrival by the owner of Zeinart Gallery where I am lodged. As agreed he meets me there, with the aim of taking me to his house. He says we can walk, but it might take up to half an hour. I leave the gallery intent on walking. Once outside, the sun attacks our heads with murderous intention. Around us the street buzzes with tenacious midday movement. We decide against walking.

In the taxi two young women are sitting in the back seat. I open the back door. Salih opens the front.

The young women glance at me in accusation.

No, no, Salih says, come over here.

After I obey, embarrassed by the sniggering of the women and their earlier confrontational stares, I turn to my Mauritanian host for explanation. Salih explains, with what appears to me as shame: Women are not allowed by Islam to sit side by side with men in taxis, as well as in other public places. He adds— not for the last time in the course of our time together— that Mauritania has remained slow to catch up with modern, secular values.

We alight and walk for less than five minutes to Salih's house. His house is designed as a room in a compound. The likeliest comparison is cheap student housing, with shared bathrooms and laundry lines.

Salih lives alone. He says later, I will not get married. Women are too complicated.

Our conversation continues for three quarters of an hour. Or perhaps double, since I fail to check the time. Salih makes tea. There is a gas stove in the room. Tea-making is a slow,

deliberate process. The condiments used must be heated to a precise boiling point, and the water repeatedly passed across several cups for filtering. He offers to teach me how.

Salih talks about his small library. His books are piled on the floor in the middle of the room. Most are in English and published in the United States, including Haruki Murakami's *Norwegian Wood* and *The Wind-up Bird Chronicle*, and Cormac McCarthy's *The Road*. Then I ask about his writing, and he shows me old and new poems. They are tempered with adolescence; melancholic and fatalistic.

As if resigned, he says that it's very difficult if you're a Mauritanian who speaks English and little French. The national writers' group treats him as undeserving of their company, as one without the prerequisite qualification. But he prefers English to French; it's the language of the world. He studied in the United States as a Fulbright Scholar.

After several awkward pauses, Salih stands to get the daraa. I notice it's the same one he'd worn two days earlier, when we met for the first time. It is the most brilliant of whites.

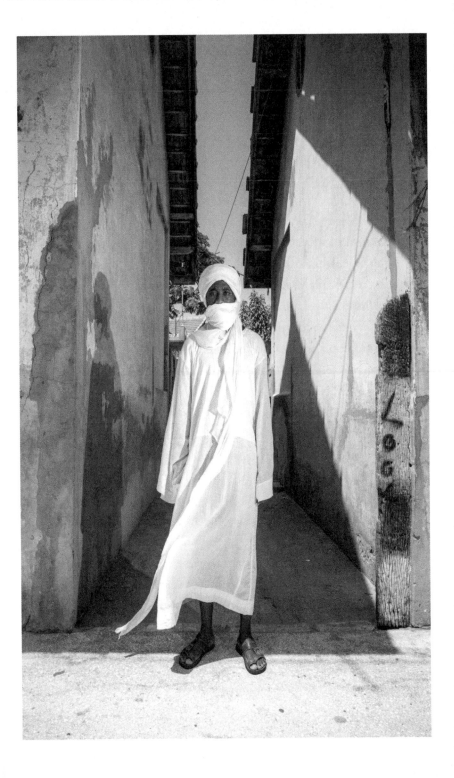

18

I consider a photograph in which, as a boy, I pose with my siblings, wearing white agbada. Each face expresses an individual sadness. We are all perturbed by the imminent departure of our father, who must return to the United States to complete his graduate studies. The agbada I wore then is similar to, and as white as, what I wear in the portraits taken during my time in Mauritania, six months ago. And my pose, which is what makes me return to this photograph in the first place, seems to have prefigured one of my poses in those Mauritania portraits.

What makes me linger, while looking at the earlier photograph, is the possibility that my body might have remembered a forgotten gesture. Standing for the shot in Nouakchott, could I have known that the resulting picture would become analogous to one taken in southeastern Nigeria, more than two decades earlier?

I place my Mauritanian portraits against events of my childhood.

Even upon my father's return from the United States I moved from one Nigerian city to another, spending an average of four years in each city. I understand that my pose as a boy and as a young man depicts the fraught moments I have carried within myself all these years: the tenseness of belonging in part, of being certain of departure.

This attempt at steadying is the lot of those who are one day in a place, the next day elsewhere. They are the innumerable wayfarers of this world, migrants of great number.

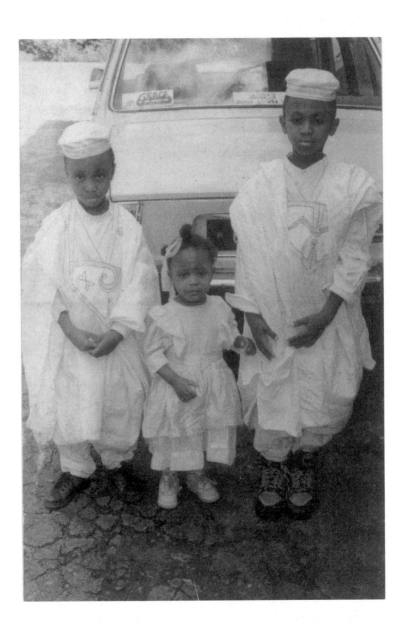

19

In the photograph I tilt my head forwards. In a short while, I will enter the car behind which I am pictured, to be driven away by my uncle, who has taken responsibility of my brother and me until my father's return. Two cars will depart, one to my uncle's house, the other carrying my father to the airport hours away in Lagos. In these departures, father will be distanced from son, and an opening will appear between us. I could understand the nature of the separation. I might know that by posing for the photograph, I create an evidence of absence.

Perhaps, also, this is why my sister, who stands between my brother and I, is pictured in tears— our father might have cajoled her to take the photograph. Each of us seems to possess the readiness required for a portrait, the awareness that being photographed is an important activity. My hands are held together— first to hold the agbada in place, since it could flutter in the wind, but also held together as if to say: This is how I present myself.

Sometimes, as an adult, I envision a labyrinth of old family photographs, or portraits of boys my age. Into this I wander, emerging with an alternate viewpoint of what I could become.

20

There was a little boy in the wealthiest district of Dakar. He couldn't have been older than seven. Unlike his peers, who chased strangers for alms, he remained still, squatting.

Accosted by at least half a dozen boys, I knew a word or two in Wolof, and said yes to them. I pointed to a shop where Café Touba was sold, and baguettes, and cigarettes. I led them there. For 250 CFA each boy could receive a sandwich: boiled eggs sliced into chunks, some butter, and pepper. Handing 2,000 CFA to the shop-owner, I paid for their lunch, and turned to resume my walk. This is when I saw the little boy who didn't run with his peers.

I knew what sort of boys they were. A marabou in the city, or further away, had sent them this way. To seek God, they would beg for nourishment. They would cling like urchins to any passerby, intoning improvised supplications, and earn their daily upkeep. Gifts could be meals, or water, or coins, or disposed clothing. Sometimes they were allowed to linger in front of a supermarket. While lingering, they could be seen playing. Before they ran to me, I saw them play football, barefoot, with a broken plastic bowl. Asceticism, at that moment, might have lost its attraction.

The boy who didn't run gestured for attention. It was simple. Standing, resting his back on an abandoned kiosk, he stared at me. I stopped, watching his calculated movements. Then I came closer, pulled by his silence.

I stood beside him for a while, eager to help. He acknowledged my presence with a smirk. Otherwise, despite my attempts to say in French, *How are you? Don't you want a baguette?*, he had no further need of me. My generosity, it seemed, turned sour when presented to him.

Many weeks later, I returned to Dakar from Nouakchott. I saw a man had worn my shoes. He managed the residential building I had stayed at during my previous visit, and now I hoped I could stay there a second time. Once midnight blue, the shoe, months after the journey began, became whitewashed and ashen. I disposed of it. I had emptied the wardrobe of everything else. Gifted to no one, only part of amassed trash. Yet it became the object of anonymous exchange.

When we met, he was wearing the shoe, and I recognised it at once. How is it possible to misjudge the value of castaway clothing?

I haven't always been as imperceptive. Several years prior to my time in Dakar, I would acknowledge the greeting of a teenage boy in Addis Ababa. He was often found sitting behind the welcome desk of Ankoba Guest House, the caretaker and receptionist. His greeting was a smile or a nod. Above him there was an almanac with Amharic alphabets, and beside it an Ethiopian calendar, telling non-Gregorian time. If I tried to speak to him, he would indicate miscomprehension with a shy glance at either the calendar or the almanac, my English impaled by his Amharic.

Routine followed. I came to the boy morning and evening, as many times as I entered and left, returning and retrieving a key.

On the day I left Addis Ababa, I brought him a gift, wrapped in a transparent plastic bag. A pair of shoes.

It was a gift of convenience; there was no space for it in my bag, after weeks of accumulating memorabilia.

There has been no way for me to ascertain if the shoes were needed, or worn.

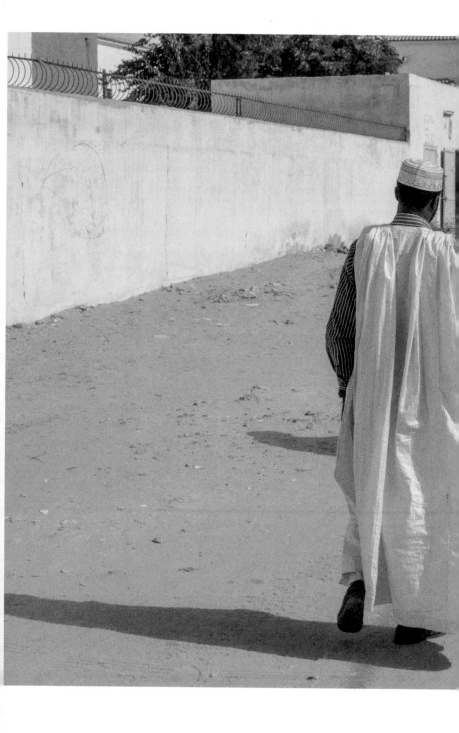

21

I walk behind a man wearing a blue daraa. My pose is similar to his: we are both pictured in a gentle sway, one foot raised, the other on the ground. The butt of a car is seen in the foreground, and the gates of a house. A white fence stretches across the frame. Shadows fall to the left. The shadows to the right are box-like. They form the crossbars of a goalpost, and the man's feet hover over the line.

22

The last time I was with Egwu, we were teenagers walking through a suburban market in Abuja. I was on holiday from boarding school. I had some money. We walked from stall to stall. I needed help in buying a pair of sandals and a wristwatch. I knew he could bargain with the traders better than I ever could. In the way he walked and in his knowledge of current slang, he negotiated the world with an assurance lacked by other teenagers I knew. As boys, I concluded this had to do with a basic difference in our lives. I lived with my parents, and he lived with a relative, as the boy who carried out all the chores in his house.

In Umuahia, where we reunite after eleven years, we are the men who recognise in each other the culmination of teenage traits. I walk down to the hotel lobby and see him fiddling with a phone. His face is unmistakable, as hairless as it had ever been, only older. He doesn't fail to recognise me either, although by now I am hirsute, a feature unforeseeable on my teenage face. We stand for an embrace and he says, Wow, this is you. He says this over and over again. I respond with laughter, adding, Yes, it's me!

Who have I become to him? We walk upstairs and I introduce him to my co-travellers. Then we sit in my room to talk. Nothing remarkable. Chitchat on our current lives. We exclaim— see how much we've grown! So much time has passed!

Later, alone, I browse his photos on Facebook. He works with a government paramilitary organisation. In many of the photos he poses with a gun, and underneath the photos he has written "Black Boy." I am amused by his outrageous showmanship. But I am, in fact, envious. Of how divergent

our lives remain, for while I amble along, moving from place to place, he holds himself with steadiness, as self-assured as the boy who helped negotiate for my shoes and wristwatch.

You are doing very well, bro.

He tells me this without making eye contact. Doing well? Either it is a truth so profound he stammers to say it, or a lie apt for the occasion, for which he has to look away. I realise as I write, it is my reluctance to share details of my life that makes his words suspect. The older we get, the greater the disparity in our experience, like paths branching away from a junction.

On certain days, perhaps once every eleven years, those paths intersect. What we say to each other will depend on the contrived expectation that we return to the same junction changed only in age.

23

In the restaurant Mr. O. takes me to, in Asaba, there is a man his age. Both men exchange a little complimentary, familiar banter. Older men whose feet are nimble as bachelors. They eat out on most occasions, preferring the camaraderie of a restaurant to the tedium of domestic life in their houses. Once we arrive, Mr. O. places an order for food, and asks me to place mine— suggesting that a bowl of soup with dried fish is the best dish here. I'd met him two nights earlier, in the company of others, including an older writer. He wasn't talkative at that first meeting. But he stayed the longest, curious about our travels, and in turn earning my curiosity about his life.

You are self-actualising too early.

He says this to me while we drink Coca-Cola diluted in water and wait for our meal to arrive. I speak little during our conversation. What kind of man has he become? He looks at least fifty-five. Throughout our meeting he draws his authority from the decades between us. Between his age and mine there is the chasm, he infers, of experience. And resulting from that chasm are stories only an older man can tell.

I am self-actualising, as a twenty-seven-year-old, by working full time as a writer. But no, a writing life wouldn't deliver on financial stability.

Look at me, he continues. I have a twenty-five-year-old boy, and now I can afford to live within my means. More children would have been expensive. So you have to figure out how to make enough money, so you can save, and plan for life when your child has left home.

I can tell that for him I am a reflection of what he imagines he was in his youth. Men like him, self-assured in their idealism, fail to distinguish their delusions from what is probable. He couldn't have known that although I nod to his suggestions for my future, I am amused by his claim to know what is best for me.

He speaks of his son, who now lives in Lagos, as a boy whose independence he orchestrated. But I sense a larger paranoia. His grown son has little faith in his guidance. There seems to have been a disagreement with the boy's mother, tainting his moral authority. To compensate for defective parental authority, he offers unsolicited advice to strangers his son's age.

I remember my father. In his own way, he offers unsolicited advice to strangers. The day we left Umuahia, where he lives, for Port Harcourt, our next stop, he joined us in the van. I knew my father would enter a part of my life— in the bus— he'd never witnessed, a life I shared with him in hesitation.

Three questions I have for all of you. How does this thing you do benefit humanity? How do you make money from it? How does it give God glory?

My fellow travellers answer my father in turns. I abstain from providing a response. And why? I could argue that being intimate with his worries, and the number of times I'd addressed them, he required no further input from me. I could argue for my response as a kind of recalcitrance, providing no answers to questions directed at me by proxy. Neither argument is truer than the other. In the van, it occurs to me that to him I bear semblance to a son whose life he didn't foresee. And this despite the fact that, as was the conclusion by anyone who saw us together, my face resembled his.

24

I hold a white plastic chair in place, bent over. The chair is broken, but the position of my body makes this impossible to see. My daraa has embraced me. The wall is part of a longer wall, and a fence joined to a house. Parts of the house are visible, including a window with several metal bars placed in front of it. On the wall, there are: a plaque indicating the address; a locked window with x-shaped bars; an opening for leaking water. At the foot of the wall: grass. It angles upwards, aimed at my bowed head.

In front of a store, I hold a plastic broom. My feet are steadied. There are other plastic brooms hanging ahead, and I incline my head towards them. The store has three entrances, and all are open. The first: a large refrigerator. The second: the edge of another refrigerator, other boxes difficult to see in the darkness. I am standing in front of the second entrance, poised as a cleaning-man, with a stack of Coca-Cola crates behind me and my shadow reflected on the nearest door. One door to the third entrance is held shut by a crate. The store is crowned with bamboo screening, fencing what is placed above.

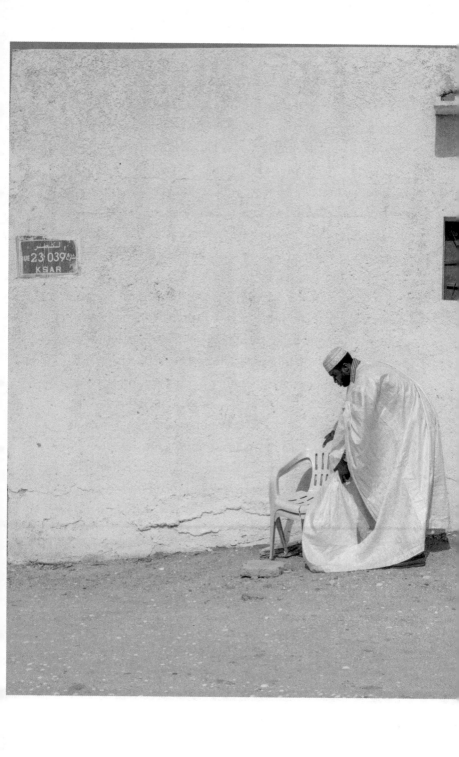

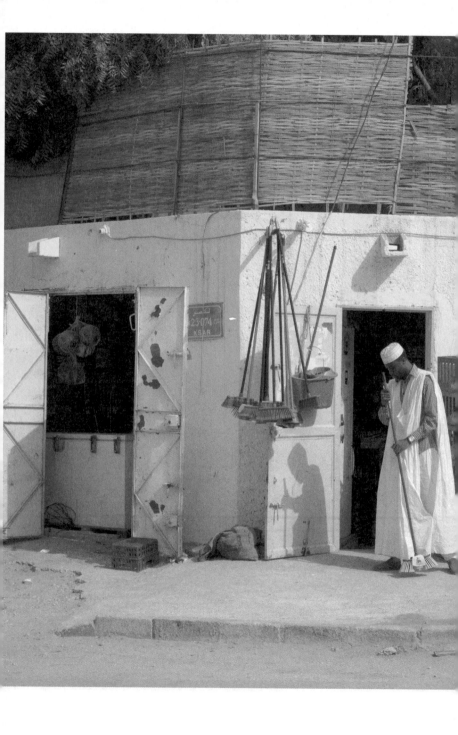

25

A photograph of a photograph reproduced in Peter Hudson's *Travels in Mauritania*: taken with my phone, it is printed on inkjet, and pinned to my wall with a thumbtack.

The photograph is of two women, one black and the other white. The way they are positioned makes a great impression on me. Their gaze is deliberate. The alliance suggested by their bodies is significant. It defies— but also makes clear— the history of traditional rivalry between whites and blacks in Mauritania, where the invading Berbers of North Africa and the Yemeni Arabs have held blacks in servitude since the 1600s.

The black Moor, who appears younger, is lying with her hand in the lap of the white Moor. The white Moor has an arm over the black Moor's shoulder. First I see women posing as friends. Then perhaps here's a servant who has earned the companionship of her mistress, who holds her, and won't let go. A friendship. A possession. Romance.

As Peter Hudson recounts, the picture of the two Moors was taken in Tamchekket, an old French fort 500 kilometres east of Nouakchott. At the time, the town had ramparts and a limp flag at the top of a short, square tower. In this town, unlike other towns Hudson visited, many of the boutiques in the marketplace were owned by women, who dwarfed the male population three to one. There were many abandoned spouses and divorcées. But, he wrote, the women went into business, asserting independence.

26

When an SUV stops metres away from me, on a sandy street in Nouadhibou, the door stays shut for a short while, enough time to give the impression that a debate is ongoing. Two adolescent girls emerge. With signs, they ask to have their picture taken, pointing to my camera, smiling in unison.

I ask them, first, to stand beside the car so they can be pictured alongside it, and then to stand in a way that puts the car outside the frame. When the pictures are taken, I hit the playback button of the camera. As soon as they have seen the resulting portraits, they say thanks and return to the car. The driver, his hands and head steadied, drives off; the car lurches forwards like a grouchy camel. I do not remember seeing him glance at the girls in all the time they interact with me. What does he think of their sudden spiritedness? And, what do they think of entrusting their presence to a stranger, gone in a flash?

27

On the first day, the woman sat on the floor cradling a baby. She was dark-skinned. A little bowl was placed in front of her, often obscured by the shuffling feet of pedestrians. There was a constant flow of people in the arcade, the oldest pathway of twentieth-century Rabat. I walked past with a hurried glance in her direction. With her blank stare, she seemed resigned.

The second day I saved several dirhams of change from lunch, then walked towards her, but met her absence. In her place there was a light-skinned woman with a toddling child. The presence of the new woman annoyed me. The absence of yesterday's woman disturbed me. And the combination of both feelings produced a curious feeling, one of obligation. Not to either of the women, or their young children.

There was another figure, perhaps from memory, whose identity and complexion were uncertain, but to whom I felt I owed an explanation. I recognised her in my mind's eye by her smile— in which only a corner of her mouth was pulled backwards, her lips were pursed, her chin was raised, and yet her forehead had ridgy lines.

On the third day, policemen cleared the arcade of street vendors, supervising them as they filled bags with their wares. The wares arranged on waterproof sheets included effigies, bracelets, sunglasses, rings, necklaces, hats, and paintings. Once or twice the sheets seemed large enough to make a tent, or small enough to fold into a shawl or blanket. I saw the woman of the first day help fill a bag, assisting a man who sold paintings and statuettes. Her crawling child was attracted by the open road and wandered towards it. The man grabbed the baby and lifted it high, rubbing its belly

with his nose. The resulting cackles kept me happy while I walked.

On the fourth day, both women were beside shop windows, only a few metres apart. The light-skinned woman sat on a mat, where her toddler lay asleep. In front of her, something I hadn't noticed when I saw her days earlier, she had a box filled with wraps of toilet paper for sale. The dark-skinned woman had neither a mat nor wraps of toilet paper, only her bowl. I went to her and dropped tens of dirhams. The coins made little sound as they landed.

As the coins dropped, I turned to her neighbour, hoping her eyes would acknowledge my generosity. She stared back as if unimpressed, but before I looked away I thought I saw her smile the smile of the unidentified woman I recognised on the second day.

28

I recall a moment in Tuti Island. Standing on higher ground and looking towards Khartoum, an experienced eye could notice where the Blue Nile met the White Nile. But my memory is an incompetent docent. Although I know I had accompanied one of my co-travellers to visit the famed island, it eludes me if the following story, told as we walked with our back to the sea, was her recurring dream, or one she encountered in a book by Jane Bowles.

Chased by a dog, she ran up a short hill. When she arrived at the top, she saw a mannequin about eight feet high. Approaching, she realised it was made out of flesh not plastic. But it was lifeless, and wore a dress of black velvet. She took the mannequin's arms and wrapped it around her waist. The arm was thick and this pleased her. With her free hand, she bent the mannequin's other arm upwards from the elbow. At this point it began to sway backwards and forwards, in see-saw motion. Mannequin and woman held on tight. Together they fell off the top of the hill, rolling downwards, until they landed on plain ground. They remained locked in each other's arms. This was the best part of the dream for her; the mannequin served as a buffer between herself and the broken bottles and little stones over which they fell.

29

On my second evening in Khartoum, we were served a welcome dinner of falafel, a tray full of bean stew, and a pile of pita bread. I observed the woman who spoke the most. Her eagerness seemed like a sprint ahead of the moment. Each person's response to a question was one-fifth of hers. And when, in an unforeseen twist of the conversation, she was asked which of the men she thought was the best-looking, she pointed at me. She was gorgeous. I noticed, despite her spiritedness, that at the moments she fell silent, the corner of her mouth would twitch, as if she pondered what to leave unsaid.

I gathered hearsay tales about her from her friends. The daughter of rich parents, she had returned from studying in Malaysia a few months before. She was betrothed, they said, but hesitant about marriage. Although curious about how far I could take my interest in her, I felt damned by time. There weren't more than two days left.

They said she was high on hashish the first night I met her. This seemed plausible. Her carriage the next time I saw her, in contrast with her outrageous chattiness, seemed forlorn.

A day to my departure, she bought a new camera, a Nikon for entry-level photographers. She brought this when, in a rare moment when we were unaccompanied by my travel companions, we walked in the Omdurman market. She began to take photographs of me framed by wares and stalls and faces in mid-chatter. These are portraits, she joked, of the moments I imagine you're Sudanese. If you write me, I will send them to you.

30

Approaching the quay on the ferry, Gorée Island reckons itself an attraction. It measures only a few thousand feet in length, a mere thousand in width. Yet one Dutch engraving depicts a rocky, lush bulge rising from the sea, approached by sailboats. When I arrive, gleaming boys dive in and out of water, taunting visitors to throw in coins. Tall, wiry men juggle balls, and wait for an onlooker's attention, even spare change. Adolescent errand girls point to restaurants, where, sitting in the shade, my food is picked at by houseflies. The Island is full of strangers, has been from the fourteenth century. Even now, run by Senegalese who live and work in forts and encampments built by European slave traders, many come to gawk at this minor port.

I am here with a travel companion who seeks out weed in each new city. I am desperate to take my first puff. While he's at it, seeking out Mouride men in their shacks near the Military Battery, I wander off.

Past the Maison des Esclaves several women sold figurines dressed in headgear, bright-coloured boubous. One stall was a makeshift canopy resting on the wall of a house. Yes, the vendor said in English, she had lived on this island for a long time, almost forty years. Her father had moved here to become a fisherman after decades of civil service in Dakar, and here she'd raised her children. While we spoke I examined some of the figurines, intending to buy one, but checking my wallet, I realised I'd run short of cash. The woman saw that I had no money and grew reticent. I asked more questions, about her profit margins and how the figurines were made, but each question seemed to annoy her.

A tourist walking past stopped with a camera pointed at her stall. After she shooed him away, cursing in Wolof, she turned to me, furtive. I smiled at her, and somehow this turned things in my favour. Sighing, she said, Yes, you can take a photograph. Earlier, at the beginning of our conversation, before asking questions about her family, I had requested a picture of her figurines.

31

One painting above the espresso machine in a café in Piazza was of an unsmiling old man peering through his dark eyes. His beard seemed a few days old. I thought about his portrait when, in Addis Ababa, I had received news about my grand-uncle's death.

But how could I forget the florid accounts of my grand-uncle's sojourn on earth? A philandering man, he was reputed to have owned the first photo studio in Gamboru-Ngala, a border town in northeast Nigeria. He was the subject of an improbable legend. Witch doctors, it was oft-repeated, invited him to their ceremonial placations of restless spirits. They asked him to take photos when the spirits re-emerged in their bodies.

32

Certain Moslems, Paul Bowles recounts in *Their Heads Are Green and Their Hands Are Blue*, did not observe the fast of Ramadan properly. They had an inclination to form cults dedicated to the worship of local saints. They organised gigantic pilgrimages, held at the shrines where the holy men were buried. Men and women could be seen dancing together— the height of immorality, forbidden by more puritanical Islamic practice. While dancing, they worked themselves into prolonged frenzy. This frenzy could result in perniciousness, like induced trances. Once inhabited by a saint, adepts could slash or burn themselves without harm.

An old woman, brought up as a member of the Jilala cult, had an experience three years before. She had grown too old to participate in the delirious observances. One evening, alone in the house with nothing to do since her children and grandchildren had gone to the cinema, she went to bed. Somewhere nearby, on the outskirts of town, there was a meeting of Jilala going on. In her sleep she rose and, dressed just as she was, began to make her way towards the sounds. She was found the next morning unconscious in a vegetable garden near the house where the meeting had taken place, having fallen into an ant colony and been gnawed at.

The reason she fell, the writer was assured, was that at a certain moment the drumming stopped. If it had gone on, she would have arrived. The drummers always continued until everyone had been brought out of the trance. But they didn't know she was coming. And so, the next morning, after she was carried home, they were invited to bring her to her senses, continuing the drumming where they left off.

33

Those days on the road, I wrote with a pencil. The faint inscriptions of provisional memories made my notebooks seem like fallow territory. I would spend hours before bed recording variations of my experience, keeping no version of myself from the page. Yet, even if that were possible, it saddened me to write each day without a clear vision of whom I addressed. How long would it take for letters of my alphabet to form an impression, moving from reading eye to sensuous heart? Then, for a brief moment in Addis Ababa, it seemed I had found my addressee.

I was twenty-three then. She was older by at least ten years, but had the looks, in my besotted estimation, of someone my age. She was meeting local artists in the city, at the invitation of the director of the city's museum. Each day I went to the museum to use the internet, and often met her there. We shared taxis when I realised we were lodged in the same neighbourhood, and while in those taxis we held each other in silence, listening to Amharic songs on the radio. It amused me that any sound at all came from the jalopy Lada cars, rickety vestiges of Ethiopian alliance with Soviet Russia.

Less than a week after we began to share taxi rides, I moved to her hotel and asked to be put up in the room next to hers. We took turns visiting each other, sitting on the same bed, sometimes watching biopics or uncut rushes of her forthcoming film on improvisational dance. These platonic interactions would last far into the night. She had a box of books, which she'd brought all the way from New York, and a box of the same size containing her clothes. Her plan was to travel to many African cities discussing art and

meeting art practitioners, with the aim of producing a book on her findings. The trip was a long hiatus from Europe, where she'd studied and lived for most of her life. Before Addis Ababa she'd been to northern Cameroon, and after Addis she was headed to Dakar.

One evening, the director of the museum invited us to dinner. He seemed eager to learn about the nature of our friendship, professional and otherwise. Would there be a co-edited monograph, or a book of essays, or maybe even a film? My companion dismissed the questions with a smile, then a scoff. The question, I felt, was one of implication: what did my companionship with an older woman make possible, and what was impossible to attain? I sensed some value in my friendship with her, and yet the prospective alliance seemed unlikely.

It was a restaurant full of chaise longues. Customers were likely to recline, tipsy, in readiness for the live Ethio-Jazz band. There was a camera on the director's neck, a Yashica. It swayed when he laughed. In one version of my uncertain recollection of the evening, a picture was taken while I slouched beside my companion, her arms around me, her head rising above mine. In another version, a more bizarre possibility, the Yashica was clicked each time the director shook with laughter, producing several blurry photographs of our bodies in the same position.

After two weeks together— a time spent discussing books and her writing and our failed love affairs— I parted with an embrace that lasted longer than a minute, and a promise to be in touch. I returned to Lagos and became lonely. Then I wrote to her, prompted by the discovery of one of her books in my wardrobe.

How have you been? You've been on my mind but I'm sorry I have been unable to call. I'll try to speak with you soon?

Five days later, she wrote back: *Do you have my book? I've been missing it and I see that you've reproduced the photograph used on the cover for an essay on your blog.*

I responded: *No, I don't have any of your books. I got the photograph from a different source.*

I wrote back to her a few hours later: *In my last email I lied. On the day before my departure, I took the book to read quickly, and forgot to return it. I was hoping to return it when next we see each other, but, alas, who knows when that would be. Which is why I didn't tell you earlier. And because I felt guilty and stupid. If you would forgive my lie and provide an address, I will send it as soon as things return to normal here in Nigeria.*

I didn't see or hear from her again until two years had passed, and then by accident, when I was travelling in Ghana for the second time and attending a stage adaptation of Cheikh Hamidou Kane's *Ambiguous Adventure*. We reunited like old friends, without mention of our days in Addis Ababa, and my little lie. But after the character who played Samba Diallo intoned a lengthy monologue, she turned to me and whispered: Did you eventually send the book? I had to leave Dakar in a mad rush.

34

Replicas, once initiated, have no end...

In Rabat, a family of five at Restaurant Ghazal: two little boys, their mother, their grandmother, and an uncle. The meals arrived. Sandwich for the older boy accompanied by fries; salad for the younger boy, although he moved from plate to plate— his brother's chips, his mother's poulet— and wouldn't stay still.

The first time he fell, hitting his head against the seat covered in marble, his mother kissed his forehead. To calm him further, she made a boat from a paper napkin. The little boy was consoled at once. He sailed the boat on the floor, on his brother's head, on the table, skilled at avoiding the plates.

The second time he fell, tripping over a step, he looked at his reddened elbow before beginning to wail. His uncle carried him to his mother. His mother kissed his elbow. A moment later, his brother stood, an amused look on his face, and re-enacted the fall— tripping over, consulting the bruised elbow, breaking into a loud cry. The adults didn't find it funny.

Such examples of mimesis in everyday life.

The bespectacled little boy on the train to Casablanca was, at first, sitting in the adjacent row. A younger boy was beside him. Their mother, who sat opposite me, wore a burqa; even her eyes veiled with gauze-like cloth. I made eye contact with the boy, who was already smiling. We began to smile at each other. Then the mother asked both sons to come closer, to sit beside me. They obeyed. Now the bespectacled boy and I were beside each other.

A few minutes passed. I was drawn to his fevered antics.

His mother gave each of us a piece of cookie. Delicious and unearned, it made me happy and indebted. I began to repeat the boy's gestures— though his mimicry, in fact, preceded mine. He mouthed his mother's words each time she spoke, in mockery, as though to pre-empt adolescent rebellion. When he realised what I was doing, he acted in anticipation. He held his chin, folded his arms, tapped his legs, looked away, touched his forehead. Each action was crowned with a smile. I repeated his gestures, smiling also.

On and on until my actions began to pre-empt his. I touched the tip of my fingers with my right thumb. He touched the tip of his fingers with his right thumb. We kept pace. I placed my fingers on the table. When he placed his fingers, he said, Piano. Then he put his fingers to his mouth, imitating a flute.

By now the train was at the penultimate stop before Casablanca. His mother commandeered her boys to stand. The boy, my playmate, grabbed their luggage and walked past. Then he returned for a brief while, counting to my hearing and glancing in my direction, accomplished in mischief.

Un, deux, trois, quatre, cinq, six…

The 10.37am train to Tangier was late by ten minutes. Prospective passengers alleviated their wait in ways commensurate with uncertainties about the train's delay. Thumbing through the day's newspaper, exchanging jokes with their partners, pacing, making a phone call; a thin man with a teenage son, two young daughters, and a burly wife sat disengaged and solitary, staring at the empty tracks. The waiting area was crowded, all but a few seats taken. A limping man walked past. He was in his sixties at least. Carrying a bag and a cane, he wore a dark hat. I paid no attention. He'd

walked a few yards, but when I raised my head I saw him sitting beside me, sighing, relieved, mouthing an inaudible thanks to the man who stood for him.

We kept waiting: his leg outstretched, his cane motionless and propped by the seat. From his bag he pulled out a folded sheet of paper. It revealed several diagrams of the interior of hands and feet. The names of ligaments in French and Arabic. He looked closely at the diagrams, pointing to name after name. On occasion he moved a finger as he muttered the names, committing to memory what was otherwise hidden.

Who was he? An arthritic man undergoing self-medication? An overage student training as a rheumatologist? A rheumatologist in rehearsal?

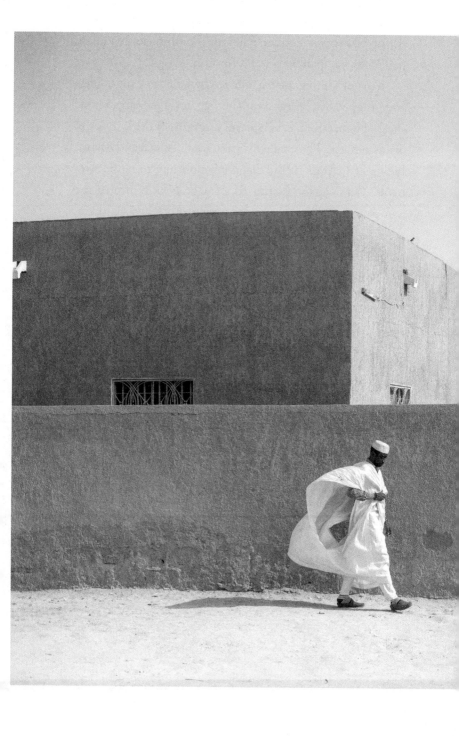

35

One hand holds my shoes; the other is raised, a few inches from my face. I approach a fenced mosque, with my shadow falling across its entrance. One part of the gate is shut, leaving space for a single entrant. The walls and the fence are brownish, just like the sandy ground, but with a darker hue. On the highest deck, three horn-speakers point in different directions: frontwards, leftwards and rightwards. A man glances towards the exit. I doubt he sees me. But he is looking in the direction of the photographer.

36

Now I am walking away from the mosque with a bowed head. My shoes are half-worn. My raised foot is skewed in motion. The daraa trails behind, broadened by the wind. Another building has come into view. From the back, it appears to have been built with concrete and plastered with red mud. The walls form squares and lines. They have the semblance of evenness.

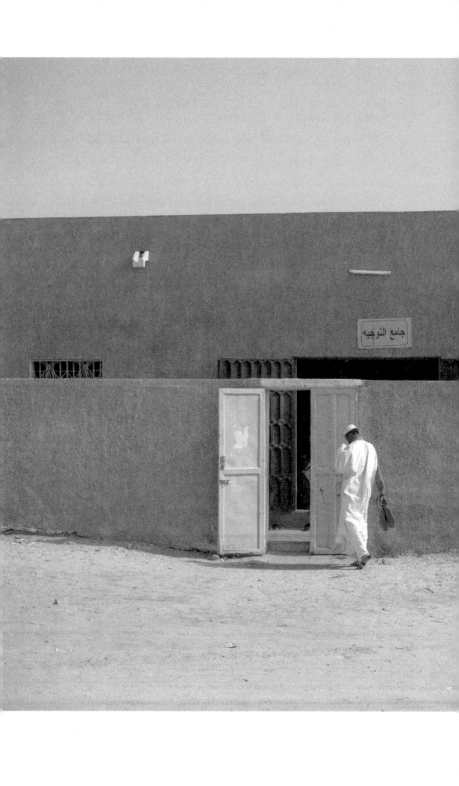

37

For the first time in my walk, I am at ease, less concerned about a confrontation, or of any human presence. I see a fenced cemetery with a broken gate. A small thoroughfare separates the cemetery from where I stand. I cross the narrow strip of road and begin to climb sand dunes as high as my ankles. Near the gravestones, the sand disintegrates under my feet, as if each step is false.

It becomes a solemn time. A moment of lingering unease. I feel apathetic to the camera I carry. A person who is photographed in a graveyard, I imagine, in a place where the mourned reside, also becomes an object of mourning.

In the cemetery there are two men who look at me, but also at the camera, with undisguised suspicion. I wave at them, declare peace in Arabic, and they appear to accept this as guarantee of my good intention.

The men, it seems, are fixing a scarecrow to one of the graves. I watch them from the corner of my eyes, seeing the insensate figure from a peripheral vantage. I notice its hands are raised above its head. Why would grieving men install a doll on the overhanging part of a grave? My first guess is of the tutelary nature of the scarecrow. In some way or another, one can be protected from evil spirits lounging in cemeteries by portraying them.

But I also recall Khnum, the Egyptian god of creation. With his rotating potter's wheel, he fashions human beings. Each person comes in two corresponding forms. The other, disembodied, form is known as ka. When a person dies, the ka does not go with him, but to the graveyard to live with his mummy or funereal statue. The family members bring it food for its sustenance, to ensure its continued survival.

In its eternal life rests the assurance of resurrection and immortality for its master.

When the men leave, I decide against taking a photograph. I perceive a camera desecrates what must remain unpicturable in a graveyard.

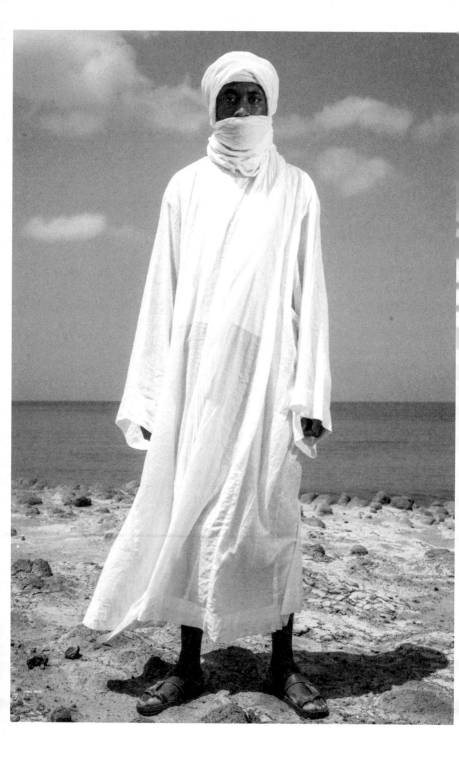

38

Someone I know, born to devout Christian parents, came into this world a triplet. In their twelfth year, both of her brothers died and her parents were thrown into mourning. Except in the first year of their children's lives, the bereaved couple had allowed only a few photographs of the triplets sitting together. Their Christian convictions had restrained them from taking more—by making photographs they acquiesced to the demonic traditional Yoruba belief that twins were sacred children connected to the spirit world, whose entwined presence were to be commemorated forever. This was unbiblical, they said, for each of us would be judged by God separate from our kin. Yet upon the death of their sons, and since during mourning we cast about in our mind for meaning, they became obsessed with having a photograph of their grown triplets, a permanent keepsake of an entwined existence.

The only way they could do this was to reinvent, through photography, the Yoruba belief that when a twin died, an artisan had to be commissioned to carve a small effigy as a symbolic substitute for the soul of the deceased twin— or two small effigies if both twins died— so that the immortal soul of the departed would be hosted by the graven image, and the dead would remain as powerful as the living. And so her parents commissioned a photographer to take a picture of the girl, first dressed as herself, and then dressed as her brothers. The photograph of the girl dressed as one of her brothers was then printed twice and placed on either side of the girl's image. The resulting picture showed the triplets sitting together. As an octogenarian, she recounted this to me, showing me the picture, as her eyes were fighting tears.

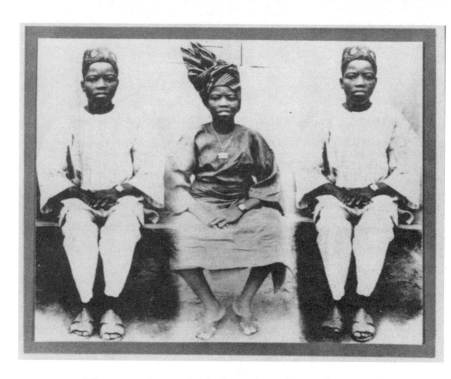

There are those who believe that cameras carry ghosts within them, and that ghosts come into view when a photograph is made. I remember an incident confirming this. As the story goes in *The Famished Road*, a photographer was taking pictures of a large group, and then portraits of certain individuals within the group. An odd explosion followed the camera's flash. Stunned ghosts emerged from the light and melted at the photographer's feet. For each picture the photographer took, five in all, the ghosts kept falling at his feet, still dazed by the flash. Fascinated by the camera, they climbed on him and clung to his arms and stood on his head. The photographer, who happened to be drunk, wasn't bothered to return to the studio, so he hung the camera on a nail in the house. The spirits encircled the camera. They kept pointing to it, talking in amazed voices. Were these ghosts who came into view as a result of the camera's flash the unseen replicas of the photographed individuals?

39

Sometime in 1994, a conversation ensued between a photographer and a writer, one eighty-six, the other sixty-eight, both respected around the world.

The photographer said: Photography doesn't interest me any more. The only thing about photography that interests me is the aim, the taking aim. I gave up photography twenty years ago to go back to painting and above all to drawing. Yet people keep on asking me about photography.

When he finished speaking he picked up his camera.

The writer said: I want to ask you something, please be patient.

Me? I can't help it. I'm impatient, the photographer replied.

The writer persisted: The instant of taking a picture, *the decisive moment* as you've called it, can't be calculated or predicted or thought about. OK. But it can easily be lost, can't it?

Of course, forever, the photographer replied with a smile.

The writer pushed further: So what indicates the decisive split-second?

I prefer to talk about drawing. Drawing is a form of meditation. In a drawing you add line-to-line, bit-to-bit, but you're never quite sure what the whole is going to be. A drawing is always an unfinished journey towards the whole...

Before responding to the writer's questions, the photographer put down the camera without using it.

In the late 1940s, possibly 1948, the Nigerian writer Amos Tutuola wrote a letter to the director of Focal Press, a reputable London-based publisher of photography books. He would like to know, he wrote, if the press would consider

a manuscript about spirits in a Nigerian forest, accompanied by a photographic illustration of the spirits. The director, more amused than interested, requested the manuscript. When *The Wild Hunter in the Bush of the Ghosts* arrived in London months later, it was bound with twine, rolled up like a magazine, and wrapped in brown paper. The sixteen negatives accompanying the seventy-seven-page handwritten manuscript turned out to be snapshots of hand-drawn sketches of spirits featured in the story.

In 1811, a hand-drawn portrait of a silhouetted man seen from the side was used as substitute for an author's photograph. The book recounted the life, history, and unparalleled sufferings of John Jea, a former slave and self-styled itinerant African Preacher. It was printed for the author at "Williams, Printer and Book-binder, 143 Queen Street, Portsea."

Jea's portrait could only be hand-drawn, as photography was yet to be invented. Tutuola's drawings could approximate what photographs couldn't. I think of that traveller in the bush of ghosts, and with what sleight of hand I could imprint his unparalleled travails on paper.

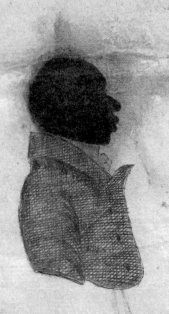

JOHN JEA.

African Preacher of the Gospel

40

The state library in Enugu, a gloomy building with varnished walls, broken shelves, wobbly tables, bored librarians, and stacks of dusty books, has on a wall close to its entrance a quote by Montaigne. It was commissioned in 1958. The building had survived successive Enugu State governments who repeatedly allowed a budget deficit.

In 2016, when we visit, it is a library in name only. What character it could have had as a house of books is replaced with blatant practicality. A place where people come to keep a rendezvous, to make photocopies, to pass time, or to initiate romance. If they read, they come with textbooks and sample examination questions. The library's users are students for the most part. While this could suggest a studious Enugu population, it brings to mind a reading habit contingent on schoolwork.

And yet. Upstairs, in the Nigeriana section of the library, there are newspapers dating to the early 1960s. Since its inception, except during the thirty-month Biafran War, the library has collected newspapers daily. The room where they are stored overlooks the largest reading room, making it a reserved place. But the room is unable to contain the newspapers, bound month by month. Some are piled high beside shelves, reaching as high as the railing, dusty and yellowed.

I go into the room with a co-traveller. We search for nothing in particular, hoping instead for chance encounters with past events. Thirty minutes in, I recall my fascination with events leading to the death of Ken Saro-Wiwa in the second week of November 1995. I resume my search with a fresh prompt. In the *Guardian* of that month, there is news

about his sentencing, calls from national and international organisations for General Sani Abacha and the Armed Forces Ruling Council to suspend the sentence, and essays on the implications of his possible death. There are several images of him and the nine others sentenced.

Beside most of the text, his famous photographs are used— in one a pipe angling from his mouth, in another his hands raised, a man of the people, his face lit with the hint of a smile. But in a less prominent photograph, which seems to typify the severity of that month, Saro-Wiwa sits beside others on a bench. It's a courtroom, and they are cramped. He's hunched over in a listening pose, resting his arms on a desk. Even in the blurry image, I notice he's irritable, as if perturbed by his complicity with a trial so farcical it would end in the pronouncement of his guilt. I look closer to confirm it's not resignation I see. It is hard to tell. An accused man in a military tribunal is under the weight of a different kind of injustice. Injustice so inhuman it seeks with one action to outdo the previous one, until what's left is the victim's soul, incapable of self-pity. This is what I'm convinced of in the photograph.

After fifteen minutes of search, I approach the date of his execution. The movement of my fingers is by now frenzied. I notice I am trembling. I fly through the pages, but here and there I pause to take note of headlines. As with a favourite film, I relate to the events of that November interested in something more fundamental than plot— such as the particular movements of a hand, the variety of inflections in a monologue, or the length of a scream. What language is used for Saro-Wiwa's guilt, or innocence? Whose words are tentative, who is a bystander?

I am startled: the copy of *Guardian* for November 10, 1995 is missing. There's a leap from November 8 to November 11. The missing newspaper could be a benign act of omission. But for me, as a result of this strange loss, I imagine Saro-Wiwa's execution as a lacuna in Nigerian history. The restless moment difficult to inscribe or forget.

41

Above my head, a signpost with words in Arabic and French is fixed on a wall. *Boutique Tessamouh.* There's a heap of sand in the foreground, reaching up to my knees. My hands are held together, over my groin, so tight my veins become visible. In the background: two entrances with Coca-Cola in Arabic lettering, a stack of tyres, gas cylinders. Beside me, on a pole, a tyre is strung; from the angle the photograph is taken, the tyre appears like a half-circle.

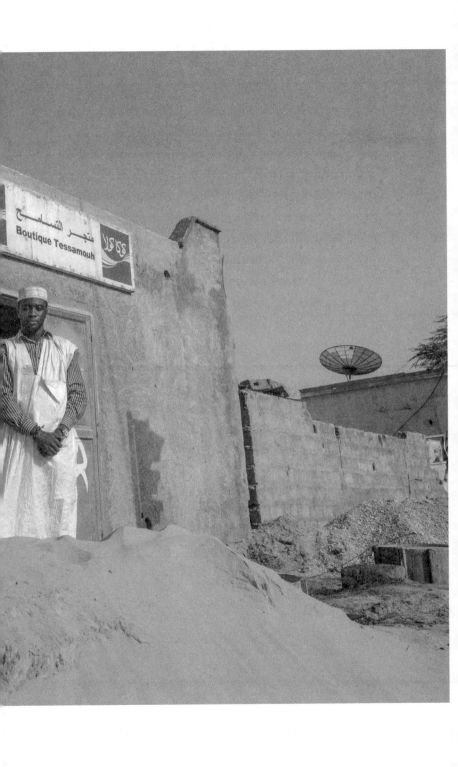

42

One story in *Intimate Stranger* by Breyten Breytenbach is about the origin of writing. Ancient Chinese lore has it that writing evolved from magical signs, from runes and the symbols or depictions of the bones cast by diviners. On the day humans began to codify the signs and their meanings by repeating them at will, without the help of diviners, they began in effect to trace the openings to the unknown. Gods and demons wept because now there was no longer heaven and earth. Humans had interjected themselves between reality and dream. Now there was a go-between straddling the known and the unknowable. Something autonomous had come into being.

Another story is about twin ladies in their great old age. They have lost husbands, and the memory of orgasms and names. They are sitting together in a room warmed by the evening sun. One turns to the other in utter uncertainty and enquires: Tell me, am I alive?

43

In the moving bus in Addis Ababa there was a man with a hood over his head. He was sitting by the window. I noticed him look at his reflection. And then he smiled— every inch of his mouth seemed to show how deliberate this smile was, and how purposeful. I was curious. Had nostalgic happiness erupted, as is sometimes the case, from the past? Then I saw another bus speeding past beside ours, which I perceived the man was also watching. I could now guess another reason for his smile: someone sitting by the window of the parallel bus, someone he loved, with whom he exchanged a conversational glance. Yet the improbability of this wasn't lost on me.

When I turned away, I noticed my own reflection. My lips were pursed. The expression on my face could have been mistaken for an unhappy one, or the demeanor of a man who wasn't considering a smile.

Again I sought the hooded man's face. By now he was looking towards me. I could claim that, at the moment our eyes met, the look on his face became similar to mine.

But faces aren't mirrors. Suppose we look long enough at others to discover their secret impulses, could we understand our own in the process?

44

There's a photograph I was given, right before I left Nigeria to study in the United States. Behind this photograph a number of lines were written—

> For the love
> of my life
>
> You and me baby
> We are going
>
> to outpace
> distance
>
> Can't stop
> loving you!

It's the portrait of a lover's face; her side gaze, kinky hair, and tentative smile. Often, when I read the inscription, which in the course of time has faded from deep black to greyish brown, I am reminded of a practice in the early days of photography, in the time of Baudelaire for instance, when intellectuals gave gifts of portraits to their friends, with a signature below the photograph. The signatures, confirming the authenticity of the photographs, also proved the extent of affinity between the giver and receiver. It was important that the photograph be one of the face, of the giver's gaze, so that the affection was direct and undisguised.

One such disguise is the screen. In the early days of each trip, I would seek Wi-Fi to see her blurry face on Skype. Each conversation thrived on the knowledge that the other

was there. In one maudlin moment I told her the minions that ran the internet sent us smileys with stuck-out tongues. Once, she asked me to look into my webcam, so that when she looked at her screen it would appear as if I was looking at her. I sent a mirror face; I reached out with a phantom hand. Were it possible to authenticate the image as in earlier times, to pass to my beloved the extent of our affinity, she would receive the mere hint of presence.

Only yesterday I made a comparison between my Mauritanian portraits and the headshot of my lover. To the photographer who had taken the portraits, I wrote:

> I worry about my portrayal in Mauritania. Except on two occasions, I stand with my face away from the camera. If, as we discussed, the project was about bridging distance, I'm afraid I now fail to see that here. Perhaps my taste has become archaic, as my ongoing research has led me to the history of the medium. But in certain ways I expect that a photographic project that attempts to collapse distances, to make strangers intimate, should have shown my face at a close level, even if in the photograph I'm looking away, or my face is held away from view. I'm eager to know what you think about this.

But having failed to get his email address, the note remains in my drafts folder.

45

The master is wearing a daraa, lying beside what seem like crates. In the first photograph, his hand covers his eyes, the way people attempt to block off light when they are asleep. In the second photograph, placed beside the first, both of his hands appear in use. One hand is on his forehead. The other hand stretches across his torso, holding a portion of his daraa.

In this photograph, the master's eyes are open. He looks like a man roused from sleep moments earlier, the daze and dizziness of not yet recognising one's surroundings. His gaze is menacing and his body is alert to the possibility of danger. Perhaps he has a percipient awareness: the photograph would be used to depict him as a shabby-looking white Moor who owns slaves in Dakar and makes them work without pay.

Is his gaze, also, one of vulnerability? Is it the helplessness of a man whose photograph is taken without consent, the desolation of a man born into a practice of chattel slavery?

Walking on the Lokoja-Okenne road, I see men with shovels and hoes, waiting. Only seven in the morning, they dally beside the road. What draws me to them? The growing number of idle men? Or, in their poses and glances, how difficult it is to distinguish them from displayed wares: bread and Coca-Cola; groundnuts and water; biscuits and akara.

A labourer's morning is lived in anticipation, as the precarious pursuit of hope. Never in my walk do I see a man leave, tired of waiting. All remain stationed. More men alight from motorcycles with work tools. Most groups— beside stalls and pavements, sitting on the floor, standing and in self-embrace, their faces lined with sweat— are comprised of two or three men, four at the most. Nothing of their organisation in Igbira makes sense to me. Only on a few occasions do they return my glances with silent indifference.

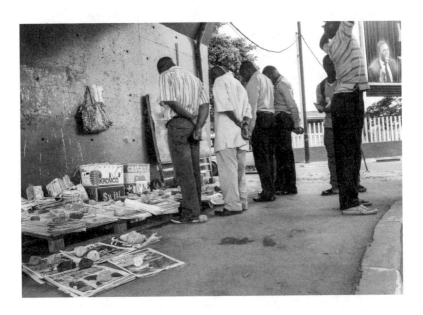

Who will hire them? Who will make them less dispensable–worthy today, worthless tomorrow?

A man who works on the street, if the street is familiar and his jobs habitual, does not tire from tedium. He is not tired from rising early to present himself for hire. He tires instead from the slow and steady viciousness of staring at the world, idle and underpaid.

The labourers I watch in Enugu carry, in a manner of speaking, the weight of the world. When they lift pans above their shoulders, place kilograms of cement on their head, or shovel gravel, they know they do a job considered of low repute. For some of them, masonry and bricklaying is a temporary alleviation of unemployment. For others, there is no foreseeable alternative, and hence they meet their fate with equanimity.

Men and women who build houses are, for the most part, considered illiterate. Their lives lack the sophistication of the educated, whose work is never menial. Of course this is true in part. Yet to watch labourers is to learn their basic wants: how to eat enough to be strong enough for the longest amount of time, for instance.

Most Nigerians know that the standard food for labourers is a loaf of bread and a bottle of Coca-Cola. There are food stalls close to each house under construction— or, in some cases, food hawkers who come daily. When these women bring food, when a man has taken a break from lifting building materials, there is an exchange of rumour, gossip, news, or experience. He receives the chatter when his body is benumbed by fatigue. At that time, seeking distraction from the tedium of mundane work, he is nourished by a staple of a different kind: stories.

Two sisters in Enugu own a food stall on a street where building materials are sold, and where new buildings are under

construction. I can't tell how long the business has lasted, but it seems they stopped working in a bigger restaurant months earlier to make it on their own. They aren't doing badly. In the time I sit with them, half a dozen labourers come and go. For each customer, there is the fragment of a story.

Do you remember the man who came here yesterday? I saw him in church, and he told me...

That woman that owns the shop nearby, there's a gist about her husband...

I saw you with that stupid boy. Hmm, be careful. Do you know what he did...

To me they tell the story of witchcraft in their hometown. The older sister has incisions to the right and left of her face. Asked about it, she recounts having a recurring sickness as a child. Her mother's blades cut her to keep the evil spirits away, to cure her once and for all.

What evil spirits? I ask.

Oh, she replies, you don't know? Children are the easy targets of evil spirits. See, in the village I come from, everyone knows who's a witch. You see her sitting in church with her legs crossed like an X. She wouldn't get up from her seat. Unless a powerful pastor realises she is sitting like that to manipulate him. Nobody goes to that town without spiritual preparation. You know that these witches operate in the night. But in my town, if you sleep in the afternoon they can come to you. Me, I am happy I have left that place for them.

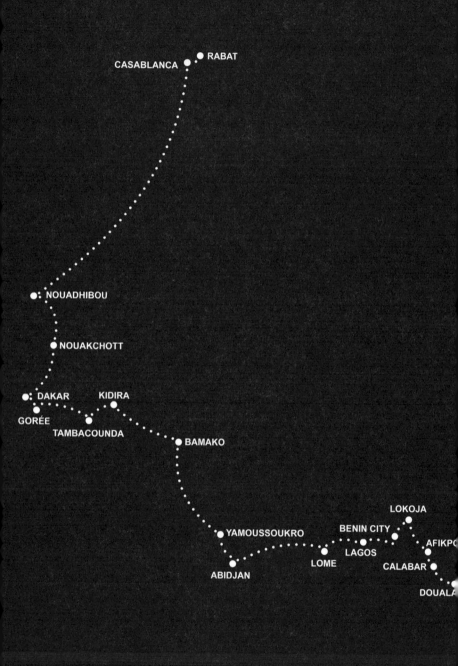

47

The day before I walk on the streets of Nouakchott I meet a rapper.

The table on which we place my things while we talk is shaky. The table holds two laptops, two phones, a hard drive, and a notebook. Each time the table shakes, the rapper does not flinch. His eyes are steady. He shows me videos and audio clips of his performances, playing them from the hard drive. He began to rap with friends, he says, when he was 15, here in Mauritania. He does not look less than 25.

It takes time for people to understand new behaviour, he tells me.

He speaks as well about the borders he has crossed, and those he continues to cross. At eighteen he moved to Paris to study Medical Engineering. While there he felt the hip-hop he performed wasn't original, so he joined a reggae band, then sometime later began to perform as a spoken-word poet. In those performances he spoke mainly French and Bambara— the dominant language of Mali and parts of the Upper Senegal River Valley— reserving English for hooks.

His next performance project, he says, will be a *spectacle vivant*, which can be badly translated as live performance. It will be the story of a half-crazed guy who lives in a town near the desert. This guy begins to walk, without explanation, into the desert. While walking he finds a mask on the floor. Each time he puts the mask on his face, he begins to live a different life. He keeps walking and there's a storm in the desert, and he finds himself near a tree. The tree speaks to him, and he spends several days under it. The tree tells him not to be sad. With time his feelings shift, from anger to

thoughtfulness, until he is no longer depressed. And this story is told with the aid of images, drawings that appear like the strokes of a gifted teenager.

While the rapper speaks, I feel the urge to pull his beard, lush and finely combed as it is. I imagine mussels fastening themselves to a fixed surface, and imagine, also, that he has the nerve for fundamentalism, the kind of which I cannot tell. It's his face I continue to watch throughout our conversation— the movement of his mouth, producing speech in English full of halting sentences. And the slight glimmer of distraction in his eyes, suggesting he has other plans for the evening.

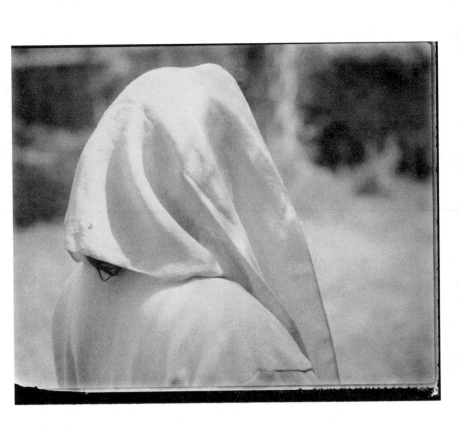

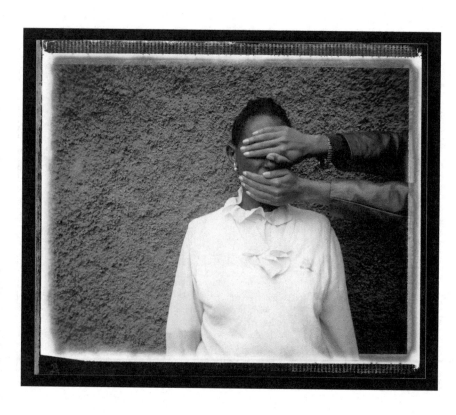

48

Here's what I recall: a portrait by Samuel Cotton in his book on Mauritanian slavery. In this portrait, Aiichanna Mint Abeid Boilil is being hidden from her enraged master in a tent by officials of a Mauritanian anti-slavery group. She is staring, as if at the entire world, accusing without reservation. It is night, the tent where the portrait is taken is dark, and a hand is holding up what I perceive to be a candle. Perhaps this hand is Aiichanna's, but I notice that it's because of the light from the candle that I can see her eyes. These eyes, embodying the real meaning of the word candid— to make white or bright, to glow, to shine— dare me to think they are inseparable from the light that illumines them. It is not only her eyes. Her entire face, wrapped in what seems like a hijab, staunch black, glistening, seems to exist in that moment only because of an illumining presence. Her whole body is full of light. Even her legs, supposing the portrait had captured her body in full, would be clothed in this light; those legs with which she had escaped, seeking an end to subjugation.

The first thing I look for in a portrait is the eye.

49

There is a little boy in Yvonne Owuor's *Dust* who has grown up close to water. He is on a boat in the middle of a lake. He sees neither east nor west, only water. He has never learnt how it is possible to see pathways on a sheet of water.

How do you know where to go? he asks the boatman with whom he travels.

You carry the way, the boatman replies.

How can I find it, he asks again?

Ask your eyes to show you where to look.

Ask my eyes? How?

The boatman laughs, and then says, That question reveals your dense blindness.

But later, once the boy had been rowed ashore, the boatman tells him how: Go to the beginning. Every lake holds the memory of its mother, it is to her it strives to return, imagining roads that we follow home.

One day at dinner, while Manthia Diawara was making *One World in Relation*, his film on Édouard Glissant, the filmmaker turned to the philosopher and asked, How can I simplify your ideas for a wider audience? Glissant looked at him and smiled: If I were you, I would wait until we were in the middle of the Atlantic Ocean, then point the camera at the mass of water, its abyssal expanse. And that would be the whole film in one shot.

The ocean is the world, without partition and division, only depth and expanse. Because of its depth, it serves as a burial place. So if you point a camera at a mass of water, you get an opaque representation, of gods and languages and objects and songs, everything thrown in with bodies from

the West African coast. The opacity of the sea is therefore its rich, dangerous promise. Some will drown, and some will reach harbour.

50

I can recite distances
by heart feet memory

I can tell wanderlust
rounded as the eyes

A walking eye sees itself blind
A roving leg crumbles into a pause

The only thing a man needs
is a suitcase and a soul.

51

Four young men in a tent: each pair of hands seems indistinguishable from the rest. The only man who is not dressed in a daraa interlocks his hands with his legs. Unlike the others, his buttocks appear to rest on the rugged floor. The man beside me holds a hand to his chest, in pledge-like manner.

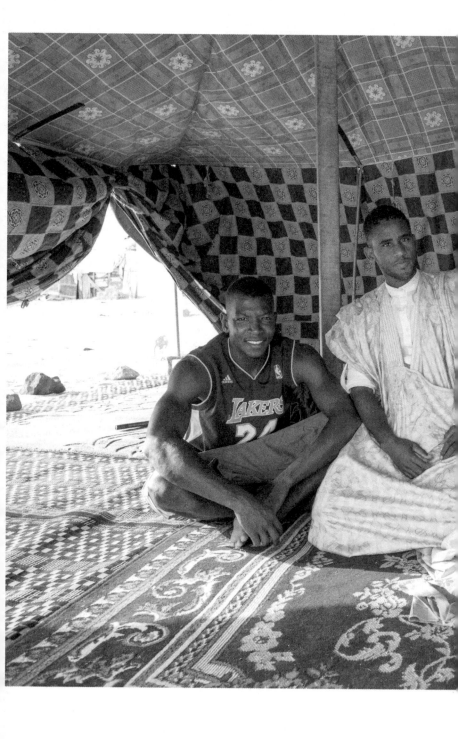

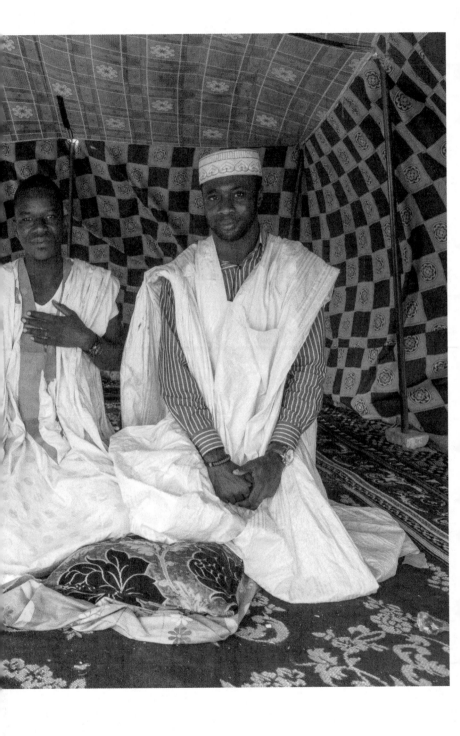

52

In Bamako, he is known by a byname, which he tells me with no hesitation. But his actual name, Gabriel, he tells me in a whisper, in confidence.

When I tell him our mission— overland from Lagos to Sarajevo, along the coast— he says he's happy we aren't travelling through the desert.

There are many burial places in the desert, he begins to aver. We find stones in the desert. We remove the stones, and see a decaying corpse. The name on the document remains legible. This is how we recognise the person.

In the desert, death means nothing.

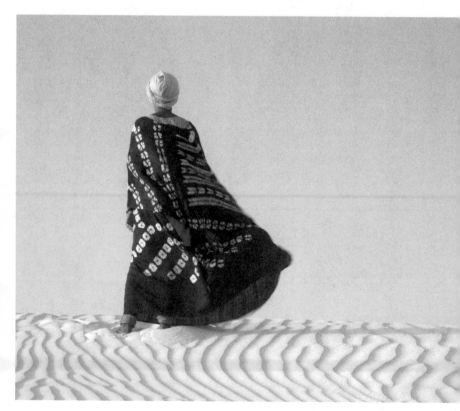

53

Mauritania was referred to as *le vide*, the vacuum, by early French administrators of the territory.

In one of Lejam's Mauritanian photographs, a woman stands with her back to the camera. The hem of her long dress is inches away from wave-like dunes. Her bare feet are steadied on the ground. Her ankles are visible below the folds of her jeans. Her garment sways, spurred by the wind. She stands surrounded by nothing but sand and sky. Is she pictured in a vacuum?

I see how Lejam might have seen this woman: a body that tells its tale in anonymity becomes one with other unnamed bodies, falling perhaps in the Sahara desert, from thirst and hunger.

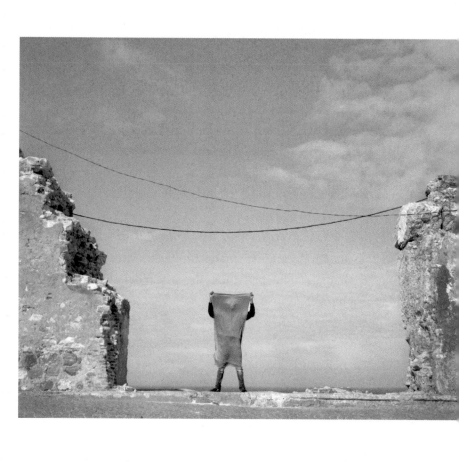

54

Lejam returned from his travels: first west and north Africa, then south and west Europe. There was a world prior to my journeys, then a world after. He told me this.

The people I have seen, the people whose stories I cannot forget, he said. The people who will die trying to cross over.

The young boys encamped behind a hill, possibly in Ceuta, waiting for the right time to make a run for the fence. Day after day, waiting. For some, year after year.

Being driven to the border, Lejam asked the driver to stop close to the foot of the hill. About twenty-five boys encircled him, their number rising like water finding its level.

There are portraits of all the boys. There is also a list with their names, ages, and countries of origin. None of these documents have been shown to the public.

Here is a possible list, with gaps, in place of all the present and future boys of that Ceuta encampment—

1...
2...
3...
4...
5...
6...
7...
8...
9...
10...
11...
12...

13…
14…
15…
16…
17…
18…
19…
20…
21…
22…
23…
24…
25…

55

In Kidira, as I approached the border station a hundred paces away, I stopped to catch the words of a man standing by himself, reclining on an electric pole. The street was busy: idlers mingling with passengers; hooting cars synchronous with bleating goats. The man's head was inclined downwards and his voice was subdued as a whisper, but I'd been walking so close I heard him.

He said: Today and tomorrow, God's time is the best.

His backpack, similar to mine, looked emptier and ragged.

I stood beside him. For a minute or more, he didn't look up. When he did he smiled, and when I smiled in return I got the sense that there was potential for conversation, a story.

I told him I'd like him to read a book.

I can't read well, he said.

Then I'll read some of it to you.

It was mid-afternoon, and hot as hell. This is not a cliché; people say Kidira, and the neighbouring Kayes, are the hottest towns in Africa, set in a bowl surrounded by hills full of iron-bearing rock.

Then we sat under a mimosa tree. The words I'd heard him repeat were the same used often in the book.

I wasted no time.

It seemed timely that a man standing on the roadside agreed to read a book I carried around. The uncanny comes unrehearsed.

I was making this trip because I chose to write a book about the Senegal River and its tributaries, and the lives of the people who lived along its banks. I wasn't courting a better life in Europe. His ragged backpack told the opposite— his travels were an imperative harsher than a choice.

I had read only the epigraph before he stopped me. *Even a life full of holes, a life of nothing but waiting, is better than no life at all.* In the length of time his eyes remained closed, I thought he had fallen into a trance. But soon his face was folded in a frown.

He spoke with his eyes shut: I have been travelling for a long time, going and coming many times. I have even gotten as far as Tangier, then sent back. Then got there again, then sent back again. See this paper I have, I got it there.

It was two-sided, crumpled and timeworn, advertising an exhibition of photographs. Two children in the picture were playing in front of an advert box in a port's transit area in Tangier. The ship in the picture was luminous with florescent light, harboured on a blue sea, or approaching anchorage, calm as a stone.

56

I am in Kidira, waiting...

My friend was arrested. We were standing in front of a train. I told him this must be part of the Dakar-Niger line. I took the photograph with my phone. Two policemen approached us. They asked for identifying papers. I brought out my passport. My friend had none. When he was being taken away he smiled at me. But his face contracted into many furrows, and he held open his palms like a supplicant. I watched him retreating, half-expecting he would turn to look at me. He didn't. Now it was clear that our relationship was not one among equals.

I have waited for his reappearance. I have dreamed of him reclining on an electric pole reciting a chant: Today and tomorrow, God's time is the best. I have searched for him. I have been warned by policemen against circling the border station, peeking through cobwebbed shutters. Yet without his name I am told I cannot be given any information. In the dozens of hours we spent together, I didn't ask for his name, and he didn't ask for mine.

I have known many shames, but none like the afternoon of my friend's arrest. I recount this encounter to transfer some of that shame.

This is the photograph of two carriages of a broken train. It becomes many things when I look at it. But most of all, it becomes the end of the world, *le bout du monde*.

57

The world is a small place for vagrants!

A man wanting to cross into Europe had friends who had gone before him. By certain coincidences I met him. He kept in touch with his friends, and in turn he told me all about their travails. They had been evicted from Libya after Gaddafi was overthrown. Then they left for Italy in dinghies and got permission to work in countries of the European Union. Later they were forced to leave Italy for Germany, but the German authorities refused their Italian papers. They organised a protest movement in Hamburg, to fight for their right to settle, protected by the law. At night they slept secretly in the basement of a cinema.

My informer disappeared. I received no further information about his friends, until I found a photograph in a book on illegal migrants— a face peering from a screen, being watched in a scanty cinema.

58

In the market, at the edge of Rabat, while I walked with Etuka, I recall seeing bound, dying sheep. The image has become unsettling. A sheep falls on its back. A trail of bloodstained mucus has formed around the corner of its mouth, urine sputters from its bladder, and, agitated, it taps its hooves. Everywhere I turned, I imagined sheep constrained in this fashion. Only bloodied futures.

Although I'd walked through public places throughout my stay, most of my excursions took place within the city, amidst its boulevards and crowded cafés, beside lovelorn couples, within a throng of people whose cosmopolitan anxieties resembled mine. In my walk with Etuka, however, I felt queasy— like a body with open, vulnerable pores. It was a poorer neighbourhood.

Etuka wanted me to feel that, stripped of privilege.

I'll show you how Nigerians live here.

There was a house we came to, four or five floors up, with barricaded verandas. With dim, narrow, and winding stairs.

You must behave normal when we get up there, Etuka said. They must not suspect you. You're with me, and we're here to relax… Except you are black, you can't go in there. Otherwise you deserve whatever happens to you. Even death is possible…One of our Nigerian sisters is in jail now. Her Moroccan landlady is troublesome. One complaint after another everyday. One day our sister got into a hot argument with the landlady. She pushed the landlady to the ground. Just a mere push. Do you know this landlady collapsed right there and died? The police came and arrested our sister and her husband, but the Nigerian community managed to get the husband out. The matter is in court.

Etuka knocked and a young woman let us in through the kitchen. Its windowsills were crammed with bottles, tins, and condiments wrapped in little plastic bags. A steaming pot sat on a gas stove, unwashed for months, perhaps, even a year. The young woman looked at Etuka, then at me, as if impatient, her work impeded by visitors of our type.

She remained in the kitchen and we walked into a sitting room with several people, up to seven or eight in all. Young men. Young women. The women wore shorts or tights. They were curvaceous, but their voluptuous bodies bore marks of overused whitening cream. The men appeared consumed by lust and addiction and hustle, whether they bore a woman on their lap, smoked weed, or discussed recent events to varying degrees of enthusiasm.

There was a child grasped by his father when he toddled towards the flitting faces on the TV. Etuka and the man shared a cordial hello. He smiled. A moment later he barked stern orders at the woman who'd let us in. A man in control. But he was lithe, youngish-looking, and his hair was groomed.

He runs this place with his wife, I was told. They own the girls.

Etuka ordered Monkey Tail, twice. Gin mixed with marijuana I'd heard of in Nigeria, but never drank. You mixed it and kept it for more than 20 days before drinking. Each cup was sold for about 5 dirhams. While he drank, he got into an argument with one of the young men, both speaking in Igbo. There seemed to have been a misunderstanding. The man had asked Etuka for a phone number, and hadn't received it. Now they debated how fair this was. Had Etuka done enough in the past to prove he was capable of looking out for a fellow Nigerian?

On our way back he asked me, again and again: What did you think?

You see that boy back there, don't mind him. He wanted me to get the phone number of a drug dealer for him. I don't want to be involved in that kind of shit. I can't help him ruin his life. If he wants to get in trouble I have no business with that.

He told me a story about himself several years earlier.

I was trying to make it to Europe. But then I came to Rabat. Imagine this. I had been begging on the street for weeks, and then one day I walked past a bank building. You know how the buildings are covered in glass. When I saw myself I stood there to cry. Is this what I looked like? I hadn't looked at a mirror in months. Maybe even a year.

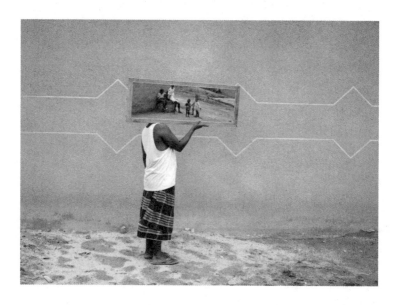

59

I have often personalized the encounter of a man baring his chest, told in John Berger's *Photocopies*. In a crowded market, I walk in great discomfort from store to store in search of a whetstone with which to sharpen a knife. When at last I find one, and the vendor wraps it up in a newspaper, I look up and see a blind man holding a white stick and wearing an unbuttoned shirt. The blind man is moving through the crowd without trouble. I go to him and place money in his open hand, but even before my fingers touch his palm he pauses, waiting for me. Holding the money, he pulls open his shirt to reveal his chest. Pinned to the inside of his shirt is a brooch, and on the medallion of the brooch I see a painted crucifixion scene. I want to touch the cross, but I feel this would be rude. After a moment of holding his shirt open, as if he is ensuring I have seen the cross, he begins to recite passages from the Gospel of St. Matthew and the book of Psalms.

The eye is the lamp of the body, he says to me, a little above a whisper, as if a ritual recitation. If your eyes are good, your whole body will be full of light. But if your eyes are bad, your whole body will be full of darkness. If then the light within you is darkness, how great is that darkness.

60

Five poles display the No Smoking sign, each pole beside caged fuel pumps, on a street in Aba with deserted filling stations where, after years of erosion, the gullied road has fallen into disuse. I know a photograph taken of me there. The wide concrete floor is steel-grey and without dirt. The roof towering into the sky reaches for the edge of the frame. Behind the roof there is a building with rectangular openings. And the openings, together, are the base of a triangle, a triangle whose vertex is blocked from view. In the foreground of everything: a smaller roof, canopying a fuel pump. The vertical pole and the marbled base take the shape of the lower half of an anchor. I wear dark trousers below a dark shirt. My trousers are folded at the edge. As I stand, the sandals on my feet are a small V. The serpentine hose dangles.

In the photograph I hold a nozzle to my head, as if a gun. With my head tilted downwards, my wishes are unclear.

61

Koursiyou said: Cheikh Bamba must have sent you.

His hair was wrapped in fabric that formed a giant halo. His necklace had beads giant like a child's fist, and the pendant like several knuckles.

While with him I sometimes thought, here now glory.

I said: Tell me more.

No one comes this far in search of Bamba's photo without being sent by him. You are on a spiritual quest. Very soon he will appear to you in a dream.

I nodded.

You don't agree fully now, but you will agree fully soon enough. We are Muslims only because of Chiekh Amadou Bamba, Serigne Touba. He told us you could be a good Muslim as a black man. He asked God: please let people who can't go to Mecca come to Touba, and let it be as if they went to Mecca.

I noticed at that moment that his middle toe had a ring. His feet belonged to a person who walked long distances on sandals with thin soles.

God granted Serigne Touba's request.

I nodded again.

I said: I want to know about the Grand Magal.

His deep brown eyes shone. He drew in his weed.

I told myself, this man is high on marijuana. Why should I believe him?

When coming to the Magal, you must bring everything you have gathered all year long. So we're working very hard now. When you bring your money to the Cheikh you put a matchbox on it. It means he is free to do anything with

it. It's true what they say: you must be in the hands of your marabou like a corpse in the hand of a mortician.

When is the Magal?

End of this month. All serious Mourides will be headed to Touba. We go to give thanks, to remember when Prophet Muhammad appeared to Serigne Touba.

I said: Sadly I won't be able to attend.

Come to Touba! Everything you need to know about Bamba is there.

And Dakar?

Nothing is here! For three days Serigne Touba was tortured in Dakar by the colonial masters. He experienced horrific things. Something terrible will happen to this city because of that. So we cannot make this our home.

The room we sat in was without doors, at the topmost part of a building in Ouakam, in front of which was written, *Aduna ay kërti kërti la! Life is movement!* The walls were covered in portraits of Mouride men taken by a Mouride photographer. The unsmiling men wore their hair like Koursiyou. A dusty low table buzzed with flies. On it, a jug of water, and a small calabash with several coins accumulated from visitor donations. I sat aslant on a V-shaped chair.

You are a writer?

I am.

There are many stories about Bamba. A lot has been written.

I told him: I'll still write.

Of course. But you must experience Serigne Touba for yourself. It is because of him I know the religion is true.

I will do my best.

At this point he stood. Beside him there was Bamba's photograph in a dirty plastic frame. He pulled it out and wiped the dust on his trousers. He handed it over.

Look at it until he reveals himself to you.

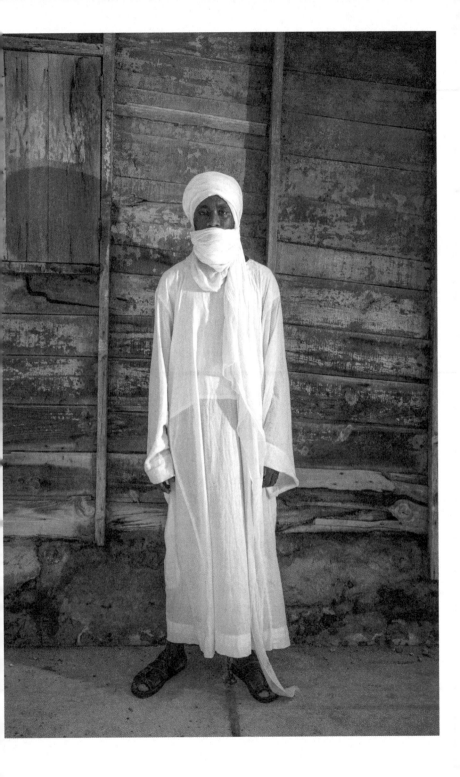

62

Many days later, I returned to Koursiyou to tell him of my dream.

I walk about reciting the shahada. The photograph is held around my forehead by a bandana. It is exactly as you know it— a saintly figure standing in front of a wooden wall and a closed door, the mosque in Diourbel. The turban around his head has formed the number 9. His eyes are sunken, and they become dark holes on a frowning face. The garment reaches his ankle. Only one foot is visible; the other foot darkened by his shadow.

I walk at once in a busy bus station, where passengers stare with indifference, and across an endless stretch of a vacant parking lot, where I am alone. All the images of the saint I've stored in my mind are projected from my head to the wall of the parking lot and the windshield of the buses: his image as drawings, lithographs, murals, glass paintings, almanacs, and postcards.

I'm also dressed in a similar way to the saint. However, my head is turbaned with a shroud, as if I await burial. When I realise this, I am in the bus station. The passengers are now unaware of my presence or the sound of my recital. As my invisibility becomes more evident, I appear in new scenes— a market, a shore, a highway, among playing boys, among chanting men working themselves into spiritual frenzy, beside a woman bowing in prayer. Once I notice my omnipresence, I awaken.

Koursiyou smiled without response. I knew without doubt that he thought the dream was fabricated.

63

In one dream I speak to a ferryman beside the Benin River. We speak about the afterlife in an Ijaw dialect. The village is so small— in one glance I can tell all the faces I've seen in my entire life, what organisation I've had with each person. One moment folds into another and I become a slave. I perceive, in fact, that when I converse with the ferryman, I am talking to my earlier self, from another life. I wake up breathless. My first thought? I am tired of these comings and goings and crossings, these several seasons.

In the dream that follows this, the following night, I am sitting with a group of friends in a throne room. We have asked to see the monarch, and he has arrived. He comes to us on all fours, charging like a bull. At first we scamper in dread, but his cortege tell us it is okay, he will relax, and so we return to our seats. He babbles about his superiority as an Ijaw king, with such intensity that only the words "Ijaw" and "king" are clear. Soon he begins to charge at us again. We realise that this time he is enraged at our sight. We flee for good. But this isn't the end of our travails. Within our sight, outside the throne room, is a roaring pillar of fire. It is flared gas. But my immediate supposition is of a landlocked town burning. Once I imagine this I see there is nowhere to turn, only towards the fire. Behind us the king is screaming, his voice as resounding as an upright man. — You cannot get anything from me, not even a story!

In another dream a friend, long forgotten, comes to me recounting a moment in our childhood. We encircled the Ajaokuta Steel Company for hours, making detour after detour but ending in front of the same taupe metal gate. Our home was a boarding school in Abuja, but the driver,

on our school bus, had made a time-consuming error. My old schoolmate is unable to recall if we eventually made it home. I am amused and terrified. If we didn't return, how are we alive?

64

I have never known myself naked in a dream. To be naked in a dream is a special kind of bareness, the bareness of the subconscious, as though twice removed from one's self. I bring this up to revisit a memory of being photographed naked, in Calabar, for the first time.

I stand in an old building, once a colonial school, now owned by a church established by missionaries in the nineteenth century. I wait to be photographed, with my back to the camera. I take off my clothes, until I am left with my underwear. But the photographer, framing my body with his lens, feels this won't work. He asks me to strip completely. Now tense, I indulge. Why tense? We had walked to the back of a building, facing a dense collection of trees, and the Atlantic Ocean. This calms me for a brief moment. It also helps that, sharing a room during the trip, I've on occasion seen the photographer naked. There is kinship, then, although it is a false one. Where I'd seen him naked in a room, he sees me naked through his camera lens, and creates a permanent record of my body in that form.

I see my body imprinted in the photograph, and perceive an imprint no longer mine. I cannot bear to stare at my naked self in a mirror, yes. But, in addition, I wonder what my naked body, when passed from eye to eye, would suggest. This virile, awkward body, auctioned off with a mere glance.

I am kin with history. The photographer, showing me the photograph later, pointed to the arched walls, shielding my head from view. The walls had aged a hundred years. What results in the photograph is an arched back, traced around the curvature of the wall: the wall and body as monument.

It is because of long-lasting walls that a mortal body claims affinity with a place.

A colonized town was a place of encounter between neighbours, proximate in space and yet unequal in power. The most senior British official in Calabar lived on a hilltop residence. The storeyed residence was a vantage point to observe the arrival and departure of merchant ships. Below, indigenes toiled to keep the ships moving from harbour to harbour, from Calabar to Liverpool. There was nothing in his relationship with the indigenes untouched by the distance of his life from theirs. And there is nothing in the relationship of their children with his legacy untouched by the startling effects of that distance.

In the Old Residency Building, now a national museum, the dining table of the last colonial official is kept in its place. A candelabrum, teacups, an off-white kettle, above them a dusty chandelier— items whose worth are alleged to be unencumbered by the passage of time. Why keep colonial relics? Why keep vestiges of an epoch of subjugation? In Nigerian museums, the colonial relic affords a glimpse of the nation, as it is now known.

There is no way to dispense with the objects through which the nation received its name.

A photograph of Flora Shaw, a journalist, exhibited in the Old Residency Building. She's seen in profile. In the photograph, her face, a part of her face, is so prominent I can see deep furrows of concentration. She is sitting at a desk. It is also possible the photograph was commissioned as a portrait. What's unclear to me, as I project on her image my preconceptions, is who owned the portrait. Would it hang over her desk, or her husband's? Whichever the case, this is a photograph in which she's portrayed engrossed in

a task— bent over, writing. How fitting her posture is: she's famed as the woman who gave Nigeria its name.

There's a joke that she thought of the name "Nigeria" during foreplay with her fiancé Lord Lugard, while in a rest house on Mount Patti, overlooking the Niger River. Jokes aside, in what circumstances did she earn the privilege to name a colony? The probable answer lies in the severity of her posture. Her photograph is passed down in this way. It carries a trace of her self-assuredness. It carries, in the wake of Flora Shaw's pronouncement— "Nigeria"— a kind of finality.

65

Not much of what I see in Koko recurs in my mind, except a grave and a bedframe. The body in question is Nana Olomu's, the Governor of Itsekiri-land from 1884 to 1894. The grave, filled with loose sand, and the bedframe, lacking a bed, seem duplicitous as monuments. What it didn't lack, in the minutes I stand becalmed, is the aura of Nana, a benevolent ghost.

"Benevolent ghost" is a stretch of my imagination. And yet: the primary intention of establishing access to the room where Nana slept and is buried is to intersect his life with that of others, in perpetuity. By now the room is part of a Living History Museum in his name, consisting of his personal effects, and documentation of the epoch he lived and worked in.

A corpse, almost in every case, is recumbent. This is why the living speak of the dead as eternally at rest. Those who speak of the dead this way realise the paradox contained in their remarks. The dead, who are at rest, leave images of their once living bodies. Two images relating to Nana concern me: a drawing and a photograph.

First, a drawing depicting the August 1894 capture of Nana's stronghold. Here is an entire army, intent on suppressing Nana's recalcitrance, and aiming to force his allegiance to the British crown. The actions of some soldiers are unclear, but most are in formation, facing a row of houses. Then: the photograph of a half-naked Nana, his neck and chest encircled by a large brass necklace. His stolid face suggests a man unfazed yet restless. The image belongs to a series of photographs taken by colonial officers

once a monarch had been captured, sentenced to exile or imprisonment. The face in photographs of that kind is the expression of a man left only with a hint of his ego, the rest deflated by oppressors.

No image of Nana's life, I daresay, is one of calm.

With these images, I return to the dark, damp room of Nana's recumbent body. I return with another man, Nana's great-grandson. Now in his seventies, he speaks with us as a guide in the museum. I notice, right at the outset of our meeting with him and before I know his relationship with Nana, an air of possessiveness. I perceive he is uncertain of his future in a low-paying job. But I also perceive an obsessive enthusiasm.

Once we sit, he begins to recount the history of Itsekiri-land, and the first settlers who arrived in Koko by way of the sea. For moments there is no pause, as he is egged on by our silent nods. Later, in the room where his forefather is laid, with his gesturing hand, he remarks on the width of the bed.

You see how big this bed is. I'm sure you now know why Nana had many sons.

66

One afternoon in Osogbo, with my travel companions, I sit facing a man who says, Prayers by the oppressed are answered at once!

He sits on a dais above us, alongside courtiers who lie on their bellies or bend both knees in greeting when he comes in. He isn't dressed as a superior. Those who court him dress in ankara fabric. But he comes in denim trousers folded at its hem, wears no socks above his black moccasin shoes, and leaves the topmost buttons of his striped short-sleeve shirt open. I can't discern if he is brash, authoritative, or if his lofty position confers on him an assurance of his worth. In all the time I spend with him, neither brashness nor self-assurance effaces what I sense is his inclination to make a distinction between telling lies and telling the truth.

He says the following:

Cheating will continue in this country until there's secession.

You ask me why?

A white man came here. He put us together over a hundred years ago. And then he left. When he left, did we sit down to say, Okay, this white man joined us together despite our irreconcilable cultural differences? No we didn't. We have continued just the way he left us. And this is why we cannot be united in diversity. Let me repeat what I said before: cheating will continue in this country until there's secession.

I'll give you an example. A Hausa man will do everything in his power not to pray beside a Yoruba man in a mosque. He thinks his Islam is superior. And you say we are one in this country? My people, I beg to differ.

So you young people came here to tell me you are travelling to understand Nigeria's diversity. Fine and good. But I ask you to think of our diversity that can never be solved. If we admitted this a long time ago, none of these agitations for autonomy we are seeing left, right, and centre will continue. But you see how unserious we are?

My own proposition is simple. We need to go our separate ways.

Listen carefully to what I am saying. I am not advocating for violence. Far from it! I am a Sufi.

You know what? This will surely happen one day. People are suffering in this country. The prayers of the oppressed are answered immediately.

Let me end by warning all of you. Anyone who uses what I have said here against me will not prosper in life. Yes. I have said everything from a good heart. If you go and you misquote me, your life will scatter. I swear in the name of God, and it will come true because this is the holy month and I am fasting today. That's all I have to say.

67

In the dark, like a slideshow of moments, memories of my travels in Nigeria return, mementos for a time to come...

One midnight I wake up anxious, realizing I have forgotten to brush my teeth before bed. I walk to the bathroom, brush my teeth, and return to sleep, falling back into stupor.

While he speaks to us about the number of dissident men he had killed, the soldier in Maiduguri drinks a bottle of Fanta. He holds it unlike anyone I'd known. He leaves the bottle unopened, and presses the cork to his lips, letting the liquid drip into his mouth.

It's sunny in Makurdi. I follow the serpentine trail of the railway tracks, leading me further into a cave. The thrill of adventure surges through me, yet I am surrounded by old and new faces. The smell sends me back.

A little boy with a gallon of petrol comes to us in a filling station in Lokoja. He smiles, places the gallon in a neat plastic basket on the bicycle, and prepares to leave. He's come from a church a little ride away, he says.

I hear, in Asaba, the voice of a man who speaks about the Biafran War: I had six sisters. Except one of them, all were raped when the federal soldiers came. But that was the small part of it... You say there were four thousand people who were massacred in Asaba. Those who dug their graves, were they counted? But even at that, we made friends with the federal soldiers.

I hear, in Asaba, the voice of a historian: If you go to marry a woman from Onitsha you must learn to row your boat in the night, in case her people say no and you have to run.

On the bank of the Niger River, I see a fisherman digging a hole, stooping to shit.

On Mount Patti, while we return from viewing Lord Lugard's rest house, we stop to dance and sing. The songs are protest songs from university. Those heady, exuberant days.

68

Notes addressed to photographers I met on the road, who request a little history of itinerant photography:

Dear…

Recall M. Bonnevide's time in Dakar, in April 1878, during a voyage of exploration to the Niger and Benue Rivers. Four times a month, the steamship *Equator* traversed Bordeaux, Brazil and Argentina, then stopped at Dakar to refuel. Those who made this stop took the opportunity to sightsee. In this they were not alone. In Bonnevide's case, however, the story of a significant exchange survives. Travellers like him, convinced that the wonders of European civilization were superior to those of Africa's interiors, were led to the so-called *Roi de Dakar*, better known as *Serigne de Dakar*, king of the city.

By Bonnevide's recollection, the king's face became radiant with smiles when he saw him put a hand in his pocket.

A poor mortal, Bonnevide called him, dependent on the charity of passengers on board steamers going to, or returning from, Brazil.

Most passengers who came to the king patronised a well-developed tourist trade. Once arriving at Dakar's harbour, his ship was surrounded by painted pirogues. Lebou boys dived into the water to retrieve silver coins tossed from the ship's deck. To the utter bewilderment of spectators, they came up from the depths with the coins between their teeth, soliciting for more action. At the dock, men offered to guide him through the city, especially the market, to see or purchase the wares of metal workers and jewellers, beads and necklaces laid out on cloths by the roadside, and local

musical instruments offered by woodworkers. Also at the dock, officials of the *Serigne* gave the king's official greetings, inviting him for a meeting.

Bonnevide offered money, four bead necklaces, and calico for his wives.

Bonnevide said: My readers would never guess what he gave me in return.

Not palm wine, or charm, or amulet. But his portrait, taken by an itinerant Sene-gambian photographer.

Nearly a century and half later, I ask you to see the king as Bonnevide did. High cheekbones, an ambivalent yet confident smile, and decked in plain-looking coarse apparel. I ask you to consider him as Bonnevide did. King of the Wolof-speaking Lebou people, his predecessor granted the French the right to establish Dakar in 1857, in exchange for costumes to be distributed to all the surrounding villages.

I perceive that the mere existence of such a king, with the sophistication of a state official, surprised Bonnevide. Dakar is civilized, he wrote after their meeting. I must take my leave as soon as possible, in quest of more genuine savages.

Dear…

Do you remember Joki?

He was an excellent harmonium player, also a photographer.

Once a German journalist met Joki in Libreville. By this time he no longer made photographs, only more and more drinking. Yet he played *Die Wacht am Rhein* on a terribly mistuned harmonium. Imagine! A man of Yoruba descent singing a German national song in 1884!

Joki was from Freetown. He was the son of slaves resettled there by the British. In his time many returnees made their way back to Lagos, or further into the Yoruba hinterland. His parents stayed back.

It is not Freetown that made Joki famous, but his work among Gabon's Mpongwe people. His photographs were often taken without studio props. He set up his tripod outdoors or in front of a bright and neutral backdrop. He took images of mission houses and portraits of women.

The women came to Joki dressed in fancy cloth, with exquisite cornrows. Occasionally a bodkin was fastened in their hair. And on occasion they were festooned in necklaces, wore rings, or carried handkerchiefs, umbrellas, and Bibles.

I don't want you to be naive! The likenesses of these women were reproduced on *cartes-de-visite* and sold to a European clientele. Whatever wasn't sold was included in a photo album indicating a specific ethnic or professional group along the West African coast.

Or perhaps the women asked Joki for portraits…

Towards the end of his life he became a permanent drunk. The gossip and lore attached to his name is that he stopped being a photographer because he drank all the chemicals used to develop his photographs.

Nevertheless I like to look at the surviving portrait of Joki. When I look at him, he has a no-nonsense gaze, dressed as a professional, focused. This man cannot be a drunk!

69

To the Ivorian man in downtown Tangier who exclaimed, The Sea is the only way! I write:

I recall when you wrote your name in my notebook.

I have undertaken several comings and goings, and alas my search for the page with your handwriting remains futile. Regardless I persist in remembering how some letters appeared: uncluttered, standalone, singular in their possible meanings...

O for an oval pebble gliding over waves, thrown by an enraptured child.

E for an unhooked prison door.

R for the silhouette of an unaccompanied woman, who for the moment reclines on a lamp post, standing in wait.

R again for a man who reclines on a wall in the medina, waiting to be hired, unsure of lunch, unsure of tonight's blanket, for yesterday while he slept in the open street drunken teenagers pulled off the blanket and fled, screaming negro, negro.

M for two interlinked figures lying on their backs, looking at the night sky.

H for two friends who cling to a fence, one holding on to the other's arm in despair, both exhausted from being hit by batons.

H again for beams that anchor the lower deck of a rescue ship where one unmoving body lies, foaming in the mouth.

P for the curve of a child's head, held aloft by despairing passengers as signal to rescuers.

U for the arms of a man who reaches downwards from a wooden vessel to grab a child, raised by men wearing life vests in deep, grey sea.

O again for the circumference of a crowded boat, where amongst other things— faces rinsed with water from the sea, hands clenched in nervousness, eyes glancing sidelong at a photographer— I see a face managing a smile.

I tried, trust me I tried, but to tell you of all the photographs from the sea I consult, in search of your face, what remains of it in my mind, the English alphabet seems garbled. So here's a dirge. If I could sing…

70

To the poet who escaped into the desert, for fear of his life, leaving his lover and son in Cameroon, I write:

I learn from an afternoon with you how grief accompanies us, separate from our beloved dead. Your dead are: a son, a sister, and a brother, not counting other relatives. All dead in the five years since you've been away. Distance, the feeling of distance, is aggravated by guilt. You didn't tell me this. But I saw on your furrowed face a question, simple yet sempiternal. Why are the living separable from the dead? Why have I remained on this side?

One day in Rabat, you sat in the Avenue Mohammed V, and spoke on the phone with your fiancée.

What about marriage? she asked you.

I give you permission to marry someone else...

Who else but you can describe the severity of failed romance? Love annulled by an improbable future. Only those who have faced a similar uncertainty might dare understand.

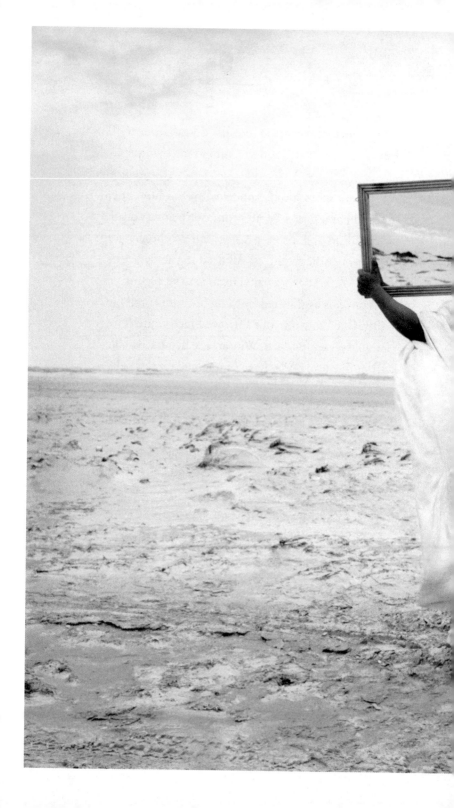

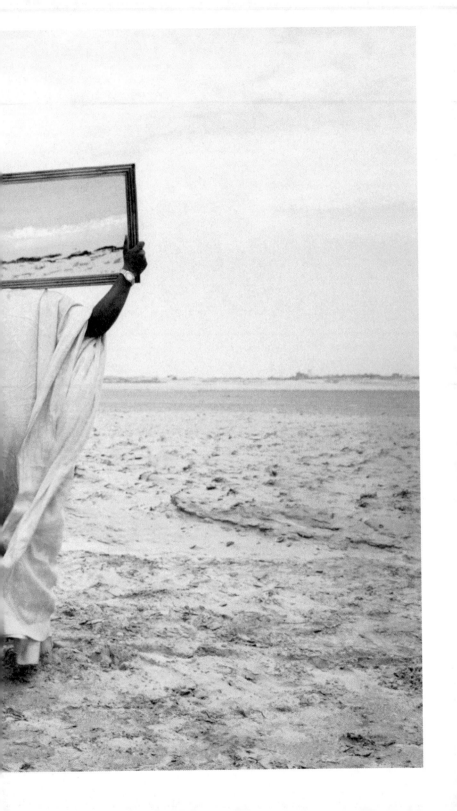

71

A note to my nephew, named after me:

My dear Emmanuel,

Will you draw a dinghy for me?

Keep it long but low.

There should be no difference between the shape of the forward part and the shape of the other end. The forward part is known as a bow and the opposite end as a stern. A transom is the surface that forms the stern. But for your boat, the transom of the stern will look like the transom of the bow.

Keep these words in your mind, my boy. Pronounce them like dates rolled over your tongue. I was once told that parts of dinghies are named after good mermaids who befriend the sons of fishermen!

Imagine your boat will carry a lot of passengers. It will be rowed slowly, wavering in the afternoon sea. Colour it deep dark brown. In the blue of the Mediterranean, against the white vastness of nothing from horizon to horizon, it will be noticeable by a rescue ship from afar.

Now you are a boat maker!

Your uncle.

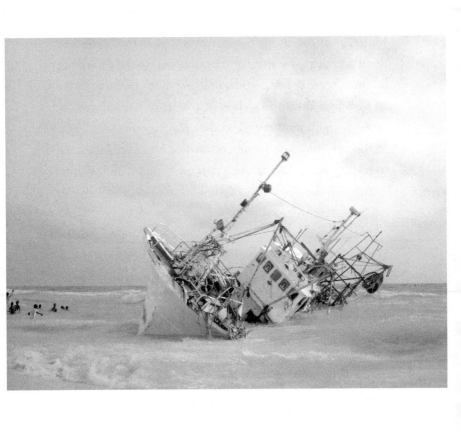

72

In *My Life in the Bush of Ghosts*, Amos Tutuola's second novel, there is an invisible magnetic missive sent to the hero from home. After over two decades of living in the bush of ghosts, he dreams a dream, which is that he is in his hometown, eating with his mother and brother, playing with his friends. In the morning, he remembers the dream and feels the need to return home. The dream recurs every night, and with its recurrence the pressure to return intensifies. He becomes neurotic, dreaming while awake, his eyes open.

Unknown to him, his people at home go to a fortune-teller and ask if he is alive or dead. The fortune-teller confirms he is alive in a bush yet has no intention of returning home, and so the fortune-teller summons him with the power of an Invisible Missive Magnetic Juju, which can bring a lost person back home from an unknown place, however far away it might be, with or without the will of the person. The fortune-teller sends the juju every night.

The hero returns home. But one day, while with his mother and brother, he hints to them that he intends to return to the bush of ghosts. Once every century, the ghosts celebrate the "secret society of ghosts." He wants to attend the festival, returning with its news to them and the rest of the world. His mother and brother warn against his attendance, yet the hero knows he will return to the world of ghosts. He'd dreamt of his presence at the festival. Regardless of their character, whether good or bad, his dreams come true.

To the reader, he says: You will hear about this news in due course.

This certainty— or, to be less optimistic, this resignation— is one shared by anyone who makes a life in the traffic of borders. A life of being away from home only to return tainted by wanderlust, unable to stay. A traveller for whom all restless cities appear similar in size and in labyrinth.

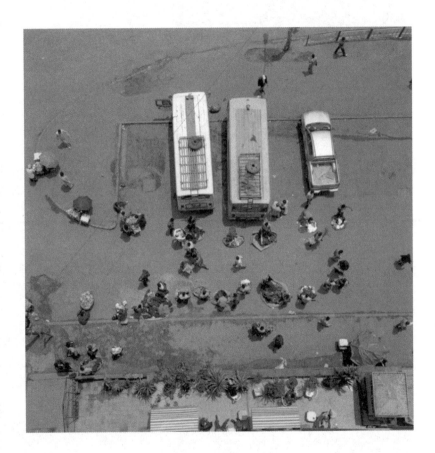

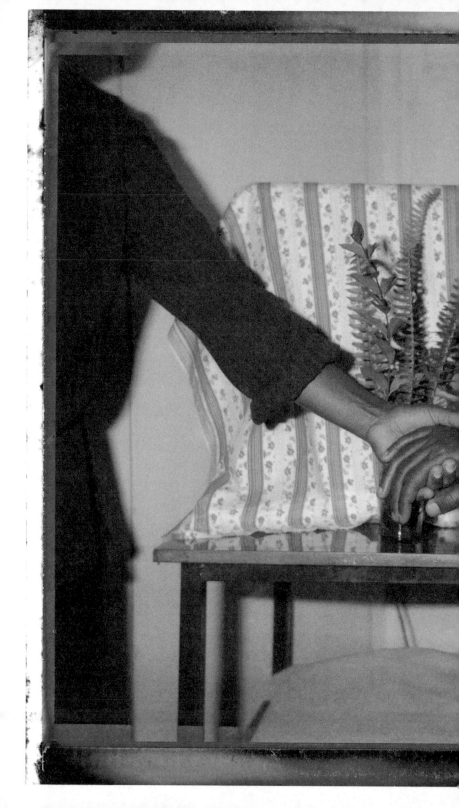

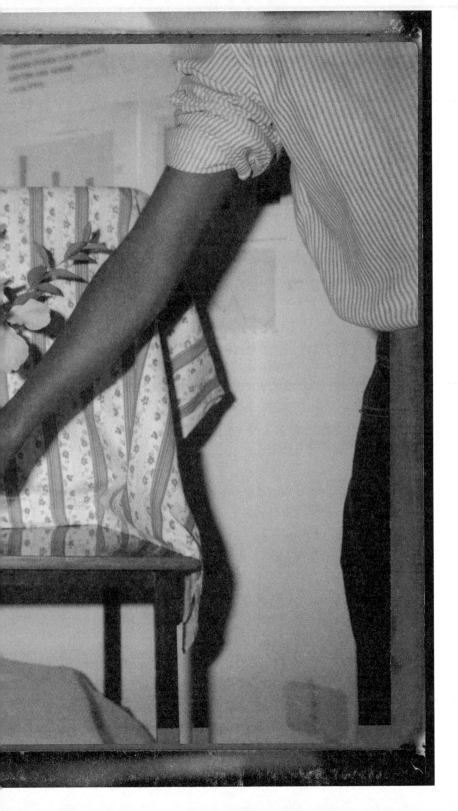

73

Draft emails to co-travellers after our return:

Dear Thomas:

Remember our hotel explorations…

In Ferkessédougou, arriving at night from Yamoussoukro, the sheep scamper, their bleating drowned by our van's horn. (Our guide is selfless. He has driven with us from Abidjan, a day's journey, and yet remains tireless. When, unannounced, he jumps into view before a photograph is taken, a part of him emerges blurry in the picture.) And the hotel is fenced, built on the edge of a road, from where we can see a rubbish dump. Its walls are plastered with coral-pink mud. Inside it is newish— not new, but giving the impression it was once abandoned in a hurry, returned to, then renovated. The entire compound is a rhombus, the rooms set apart from each other with a wall that reaches our shoulders, and the air conditioners like caged protrusions. Underneath each cooling box there is a bowl for dripping water. And, now checked in, we discover the Wi-Fi works, and everything is forgotten for a moment. We begin reaching for the concatenated world, each with separate rhythm.

In Abuja, all four of us share a room, one of two rooms behind a small hotel, perhaps intended for staff sleeping over. The bathroom is shared with the other occupant— it won't lock, the shower doesn't run, we have to bathe anxious of being seen naked. The beds are apart by no more than three feet. I see you, when asleep, stretching your arm towards the floor, to gain additional space. This always makes me smile. To maintain our individual spaces, we have made strange jigsaw shapes. (And you took a photograph of me on the

road leading to the hotel. I dislike it very much. Because of the way my incisors appear, like cartoon teeth.)

In Kousséri, our companions will tell us, when we reminisce: that was a brothel! Didn't you see the sheets being changed as we arrived? Or couples frolicking in half-shut rooms? Or perambulating room-hopping women? Later, relieved by dawn, we congregate to trade survival stories. A woman travelling with us had used her own sheet on the bed. Or else she wouldn't sleep. Even then, her nightmare was of being robbed, and she had woken with her handbag under her head. You and I slept fitfully, sharing a bed, one facing the leftward wall, the other facing the rightward wall.

In Ikom, we sleep in our van. The night is almost always long, almost always painful and tense. Chirpings continue in our hard-earned sleep. Just before dawn, struggling to stretch into comfort, feeling almost cathartic, awakened by a snore or fart, we see the unfamiliar profile of a small, rousing town. Already we can follow the trail of piquant dialogue from nearby bungalows. (We often wake minutes apart; our travel rhythm is now synchronous.) I see you grabbing your camera. I see you wiping the mist off the window, refocusing your lens. I mistake you for a sentry who, standing watch at a point of passage, has seen suspect movement. There is a man ambling on the other side, a sack of fresh produce on his head. He disappears into a film of cloud.

In Bitam, an immigrant Nigerian pastor has welcomed us to spend the night in his house. Three bedrooms and a sitting room will be shared between the man, his wife, their suckling baby, their nine-year-old girl, their six-year-old boy, and eight of us. The night is over soon, and departure is imminent. All requests are granted— water to wash our van, a place to buy breakfast, the direction towards Libreville— except the request for a group portrait, all thirteen of us. You

know I am involved with a church, the pastor says. It's always better to request permission from the headquarters first.

Yours.

Dear S.,

In Abidjan, your room had: one window; an air conditioner that became freezing in few minutes; a mirror you could only see if you sat on the bed's edge; a bathroom, narrow like an alleyway— when you sat on the toilet seat your leg touched the door; and a desk so close to the bed the chair couldn't be pulled. A small, small room. It was the kind you walked in to drunk. Channel 4 on the TV was a porn station. The manageress left it on when she let you in.

Many weeks later in Dakar we went to a nightclub. Much drinking, puffing, dancing. And sex workers swapping dance partners, soliciting the ideal customer. With a wink of an eye you completed a transaction. I saw you saunter away, tipsy, bursting with undischarged lust.

But you'll complain the next morning of the cost of a one-night stand and the unpleasant effect of cigarette addiction. When you paid only 10,000 CFA, your partner asked for another 5,000. When in the course of your orgasm she exhaled with relief, her breath stank of nicotine.

Yours.

Dear E.,

I looked again at a photograph of our dead co-traveller, and I understood with new insight. A fable by Italo Calvino told in *Invisible Cities* helped me.

The inhabitants of a certain city, to make the leap from life to death less abrupt, constructed an identical copy of their city, underground. All corpses are carried down there to continue their former activities. They are seated around tables, placed in dancing positions, made to play little trumpets. All the trades and professions of the upper city are preserved underground: the clockmaker, amid all the stopped clocks of his shop, places his artificial ear against the

out-of-tune grandfather clock; a barber, with a dry brush, lathers the cheekbones of an actor learning his role, studying the script with hollow sockets; a girl with a laughing skull milks the carcass of a heifer. (And I add: a draughtsman, bent over a canvas, holding a rusty eraser, with a satchel over his shoulders, makes the outline of a face with slacking jaw.)

The dead are accompanied down below by a confraternity of hooded brothers. But the confraternity also exists among the dead, lending a hand to their living colleagues.

Every time anyone goes down below something has changed. The dead make innovations in their city. Tiny changes, but soon the underground city becomes unrecognizable. The living, to keep up with the changes underground, want to do everything the hooded brothers tell them about the novelties of the dead. The city of the living has taken to copying its underground copy.

Actually, we are told, this has not just now begun to happen. It was the dead who built the upper city, in the image of the underground city— so that, with parallel cities, there will no longer be a way of knowing who is alive and who is dead.

Isn't it clear then, my dear, that our dead brother isn't altogether gone?

Yours.

Dear E.,

I write again. The image of Bro. Ray, you told me, lying without companion in a coffin, was of a body whose hustle had been truncated. Now, however, I write under a different pretext. To bring to your attention an old dirge, the kind that is scarcely sung, brought to my attention by Isabelle Eberhardt's *In the Shadow of Islam*. It was sung in 1903 by Si Adbelali, a man from Marrakech, while he overlooked the road to Beni-Yaho, as he watched four men carry on their shoulders a stretcher draped in white. I sing this dirge for our own sakes. One day, too, our restless travels shall cease.

Here I am, dead, soul and body divided.
They have wept over me the ceremonial tears.
Four men have carried me on their shoulders,
Attesting their faith in the one God.
They have carried me to the cemetery,
They have prayed over me, without prostrating,
The last of the prayers of this world.
They've thrown earth on top of me.
My friends walk away as if they've never known me.
And I rest alone in the darkness of the tomb,
Where there's no joy nor sorrow, no sun nor moon,
My only companion the blind worm.
The tears have dried on my loved ones' cheeks,
And the dry thorns have grown on my grave.
My son has said, "God have mercy on him!"
He who is gone toward the mercy of God
Is likewise gone from the fellowship of men.
There's no rescue, no reprieve in the land of the dead.
O you who stand before my tomb, don't shake your head at my fate.

Once I was just like you;
Someday you'll be just like me.

Yours.

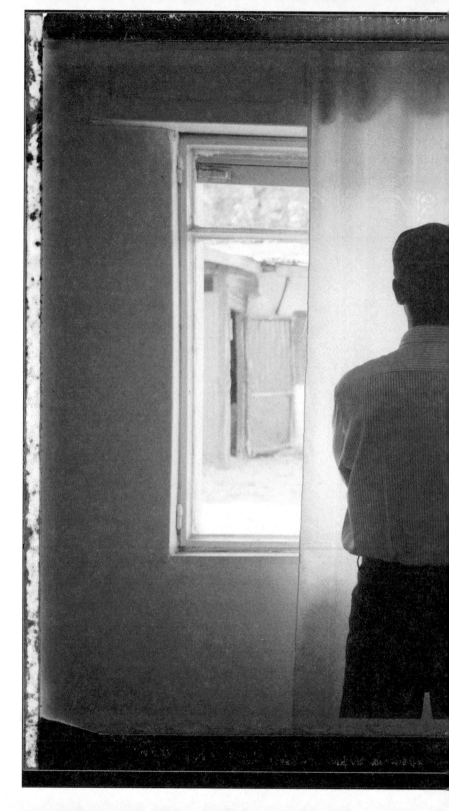

Dear Bro Ray,

I write to you despite your death. Things are clearer now. Remember when you asked me to write about your photographs, and in response I demanded to be paid? In the time between then and now, following your departure, I have realised it was the right thing to do. You couldn't afford to pay me, and I wasn't ready. But what seems gratifying is my ability to reflect on all our interactions, and all your work. This is why we say death is final: only then are we able to think of time in cumulative terms.

Do you remember, dear brother, that in the house we once stayed, it was a curtain that separated the living room from the bathroom? How we ventured into the bathroom after issuing loud warnings? In the absence of your body, do you know how consolatory it is to reimagine the house without that curtain? To imagine how our bodies moved between the rooms, unrestrained, as if through two worlds?

I still have the towel you gave me in N'djamena. The one I used until then had become threadbare— an eyesore, you said, and handed me a fresh one. Something immortal passed with it. Insignificant at the time, I now think of your gift both as a dying declaration and an inheritance.

Yours, always.

74

Stranger in Sinthian

On the phone Moussa sounds like a much older man. In person, he is young and lean. His voice is less authoritative, considerate. Altogether he sounds calm, and measured in his disposition. This might be attributed to the number of languages he speaks. His English does not have the pauses or guesses of a recent learner. Even when he is unsure of a word he does not hesitate to use the closest word, to use an adjective in place of a noun, or to approximate meaning by saying: Something like that. He is Serer. He is learning Pulaar because the people in Sinthian speak it. His French and Serer are perfect. His Wolof is spoken with an accent that sounds foreign to most Senegalese.

He is bespectacled. He comes from a bespectacled family. His father, who is ninety-eight, wears glasses with thick lenses, yet looks at a newcomer as if eye-to-eye. His younger sister Marie, also bespectacled, speaks only when spoken to, in deference. In Fatick where his parents live, he has two older male siblings. They wear no glasses, and seem to use their hands more than their eyes. Their grip is firm; their gaze is often averted. Their ages are hard to guess. After an entire life in a homestead, their gaits are as those of sages, without the brash impatience of the urbane.

If Moussa is a sage he is the kind to be found in the village centre, spirited and welcoming. Anyone old enough in Sinthian must know him or the place he works. The Cultural Centre he administers is aimed at benefitting the

villagers; helping with farming, education, entrepreneurship, and arts education.

Moussa's wife is one hour away in Tambacounda. Weeks ago, she moved to the town from the village for a new job. It is only a week since her arrival. Her new house remains bare, unfurnished, and dim. Regardless there is a sense that in the months to come the house will gain the character of a second home. Already she lives with two girls, her sister and sister-in-law, there to help with chores while they prepare to write pre-university exams. Nothing in Moussa's treatment of his wife suggests they live apart, or sleep in the same room only on weekends. And nothing he says suggests they will live together soon. To the outsider's eye— considering how difficult it must be to fake satisfaction— they are content with the current situation.

Moussa goes to the Marché Central when there's a new guest at the Cultural Centre, to shop for groceries and vegetables. He carries himself as an expert, though not in a know-it-all or show-off way. He is an expert in coordinating the commonplace and practical. Each item he orders— a kilo of carrots, two kilos of onions, three kilos of Irish potatoes, two kilos of sweet potatoes, several cucumbers, a bunch of lettuce, etc.— is recorded in a blank receipt. He inputs the quantity and amount himself. When it is time to pay he reads out the figures to Aliou, the shop owner. Aliou confirms the grand total. It seems both men are familiar with each other's needs.

Here in Sinthian, the Cultural Centre has the largest compound and newest buildings. Four smaller rotund houses flank a main building, leaving significant amount of land for gardening and two large concrete basins for collecting rainwater. The main building is designed to serve the concrete basins. Its thatch and bamboo roof forms a

curling wave frozen in motion. Some parts of the walls are eight feet high while others are as low as three feet. Aerially, the basins resemble an antenna, as if to detect oncoming water.

Two large rooms, at opposite ends of the building, house visiting artists. Between the rooms are meeting places; for the villagers, who come and go, to charge their phones; for the staff of the centre, who sit in a circle for lunch out of a metal bowl; and for nearby NGOs who host educational or health-related events.

Each morning at about seven, seven women arrive to sweep and mop the marbled floors of the buildings. They come daily, except on Sundays. They leave their sandals below the steps or in front of the rooms. In the first thirty minutes of their work, there is hardly a moment of silence between them. Whether they perpetuate local gossip or discuss recent experiences seem to be of lesser consequence than the fact that they might look forward to this ritual of congregating daily like sisters.

Fatou is one of those women. She comes on some days with her little daughter to clean the occupied room. Her initial task is to clear the plates left unwashed in the sink. She proceeds to sweep the floor, to mix bleach and detergent in order to mop the floor, and after mopping to wipe the floor with a clean, wet rag. Her little girl is inquisitive and impatient. She walks around the room imitating her mother's gestures but soon retires to a corner bored of confined watching, snivelling.

In the afternoons the Centre is silent. Hours pass without a person in sight. The silence is not uninhabited, but accompanied by chirping, mewing, whinnying, and buzzing. Insects and birds converge within the compound, cattle and horses graze close to the fence.

In the daily work of its occupants, the Cultural Centre has a predictable rhythm. Augustin and Boubacar take charge of the gardens. They water the flowers and sprouting eggplants every morning and evening. On idle afternoons they sit with friends under one of two trees in the compound, known in Wolof as *dimb*. Under the *dimb* tree at sundown maize is roasted over a charcoal stove and distributed around, amidst banter, argument, and laughter. Or cards are played; the players fling their cards forwards in an urgent, almost despairing manner.

Each staff member has been brought here on Moussa's recommendation. Boubacar is also from Fatick, a good and calm driver in Moussa's opinion. Augustin is from the nearby village of Sall where up to ninety percent of inhabitants are Catholics. Yaya, from Koa seven kilometres away, trained as an agriculturist. He is here to work on agricultural projects like teaching the women gardening skills. In dealing with Moussa they do not give the impression of anxiety about keeping their jobs, and so eliminate the blind servitude of similar workplace relationships. What they are indebted to is Moussa's commitment to Sinthian— attached to him first as friends, then disciples.

It takes forty-five minutes to walk to Moussa's farm. First the land is uncultivable, but as the journey continues there are farms on both sides of the road. Further away is the mapathanja, consisting of huts and a clearing where the villagers rest awhile during farming season. Then, a 5,000-hectare ranch owned by Baba Diaw, an oil dealer, one of Senegal's richest men. Furthermost is the Gambia River, coursing to join the Atlantic at Banjul.

An old villager asked Moussa if he'd like a farm for this year's planting season. Yes, he said. He was given a hectare in total, one half ten minutes away from the other half. In both farms he has planted peanuts and maize. The maize

farm is overgrown with weeds as high as the stalk; some of the maize when plucked is rotten.

In most of their farms the villagers plant maize, millet, and peanuts. There are cotton fields after a few hundred yards. But the cotton is bad this year as a result of overabundant rain. The rains last for about four months, from June to late October. Here in southeast Senegal, unlike Dakar for instance, the rains continue for about a month longer.

Only the village chief seems to have planted cassava. Only his farm is fenced with barbed wire and metal rods.

There are trees and fruits in Sinthian that Moussa has never seen in his hometown. Such as a stout pink nut shaped as a bulging cylinder. He pockets it to confirm what it is.

While walking in the farmlands there are children and their mothers, mostly sons. Occasionally they are with their fathers. Everyone says hello.

The first group is returning to the village in a speeding cart pulled by a donkey. In his excitement at seeing Moussa, a little boy in the cart falls to the floor. After tumbling, he runs after the others with delight. They cheer him.

The second group is a man and his son pulling two white calves.

After he visits the first peanut farm he owns, and while he is walking to the second, Moussa meets a woman with her adolescent son under a tree. Her son has set a little red kettle above stones and firewood. She brings a clean cloth for him to sit on but he declines, and proceeds on his way. When he returns from the second farm, the woman brings a white cloth for him to carry the peanuts bundled in a sheaf. Again he declines, telling her not to be so courteous. She then suggests a technique to make carrying the maize easier: You fold back a few layers of the outer covering, tying them together at the edge. This way you can lift several spikes of

maize at once. Moussa hadn't known the technique until now. Maize is not planted in his village.

Papa Sule, whose farm is close by, sends his son with maize. This is the maize Moussa is taught to carry with ease.

In the mapathanja, four women and a baby girl sit fatigued. Moussa spends time with them, mustering as many Pulaar words as he has learnt. The women are tolerant in their responses, and the conversation is stripped of superfluous words.

His sister and sister-in-law are here for the weekend, and accompany him on the trek. After about twenty minutes a string in his sister's slipper cuts loose. She manages until they arrive at the farm by dragging her foot with the bad slipper, or by walking barefoot in frustration. As they make their way back, it is impossible for her to continue that way in her exhausted state. Moussa gives her his. Then walks back barefoot.

In this village, everyone knows Moussa is grounded in ways other than ancestry. He has the authority of an intimate stranger. Day after day he becomes more familiar with customs and better at Pulaar. And while they know he will never be an exact reflection of their speech or conduct, the practical thing is to treat him as if he will.

One night Doctor Ba received a call. The voice on the other end was a Sinthian boy.

Doctor Ba, Doctor Ba, if you don't send money they will kill me! I have been kidnapped in Libya!

The boy helped around in the hospital. Then he disappeared, and no one heard from him until the night of the call. The next morning the doctor went to Tambacounda and sent the money.

When I met Doctor Ba, all I imagined was the strength of his slender fingers. He treats 12,000 patients a year, who come from a total of ten surrounding villages, with Sinthian at the centre. I rest when I can, he said. Those fingers carry an encyclopedic knowledge of the human body. In them are memories of the pulses of everyone in Sinthian, touched in the past or future.

An hour after he shook my hand, the smell of his fragrance remained on my palm.

It is possible to speak of Yelimane by observation. If you observe his gestures without sound— say, with earplugs— all knowledge becomes decipherable by the movement of his hands: what it suggests when the fingers fold into a knuckle, the index finger points heavenwards, the palms are opened in explanation or supplication, the arms bend in parallel formation and in self-embrace, and when in a mid-sentence pause a halved finger is brought close to the chin.

Observe his pencilling. It begins with faint and uncertain marks. During this initial action on the canvas, the pencil is blunt. But in the subsequent stage, once the pencil is sharpened, it makes surer marks. Line is added to line in gradual strokes of enlargement. After hours of toil and occasional erasing, the white canvas is covered in pencilled letters.

Observe his calligraphy. Eight finished paintings are strung along a cord. All the paintings are polychromatic. In the burst of colours the letters are pronounced, like incantations. The canvasses contain sentences in Arabic, Wolof and French. In one: *La santé avant tout / Ludul we weralogen*. In another: *La violence s'est endormie maudit…celui qui la réveille / Fitna mangaynelaw yàlla rëbbna ku koyyee*.

Observe his face. Sixty-four and bald, his eyes are large, bulging, and appear heavy. What's most impressive on his face, however, are the threads of hair under his chin, around his lips, and which sprout from the holes of his ears and nose. They are a mass of grey and white. They do not only give away his refusal to shave, but also that he has not paid attention to his facial hair. Some are bristles. Others are lengthy strands.

Seen from a distance, he is a wise, ageing man.

In Sinthian, at the Cultural Centre where he's spending a month as an artist-in-residence, he quickly becomes a regular feature of dawn. He walks about the main building counting his prayer beads. For a moment he stands in a pause. Otherwise he paces in a circle. After half an hour he sits on a chair. Given the design of the chair his body appears aslant. His aslant body faces the direction of the gate. Towards the gate he has fixed a contemplative gaze.

Of Saliou's biography, there are only two things you should know: he came to Sinthian with Yelimane, as the calligrapher's assistant and friend. He is from Chicago, and became a follower of Cheikh Ibra Fall seven years ago.

Of all Saliou's travel stories I tell only one.

Once, while he lived in Gambia, in a town between Serekunda and Brufut, he touched his buttocks and felt a painful lump. Several lumps also appeared on his legs. At this time he was living with a marabou called Dem, in a building with tarpaulin for a roof, dilapidated for as long as anyone could remember, home to the homeless.

He showed the lumps to Dem.

Dem said: You crossed the path of a powerful charm intended for someone else. Let me take you to my village. There I will heal you.

Saliou went with him to a village two hours by donkey cart from the Senegal border. There he was introduced to Dem's family and installed in a room. For four days Dem remained in the forests of Casamance gathering medicine. When he returned, he made Saliou bath daily with herbs and barks, and drink a bitter tea. After a few days the lumps began to disappear, one after the other. Then he was well.

But the marabou would evade questions about returning to their town. In his village business boomed. People came to him for charms, amulets, and prayers. And wasn't it remarkable, some of the villagers said to themselves, that his baraka was potent enough to attract a white man??

After two weeks of sitting in the room given to him in Dem's village house, Saliou became impatient. He had a business at home, selling Cafe Touba from a tiny kiosk. He couldn't tell if the boys to whom he entrusted the business were doing a good job. Yet, broke as hell, he couldn't return alone.

On New Year's Eve he sought out a barber's shop. He walked until he crossed the border into Senegal. He found no barber. When he decided to return, he got to the border and met it shut. We close the border at 6pm daily, they told him. And tomorrow it won't be open because we'll be celebrating New Year's Day.

Brooding, Saliou walked about unsure of what to do. Then he met a boy of about 17. I am looking for a barber, he told the boy. He was in luck. The boy was a barber, but kept his clippers with his friend. They took a motorbike

to search for the friend. They found him, and his clippers. Saliou was shaved.

I have no place to go! he told the boy.

So they went to the boy's family in the village of Diouloulou in the Casamance territory. Saliou was given food and clothes. After New Year's Day he spent two additional days there. He walked about the village. In this southernmost part of Senegal, the Casamance River flows and curves along palm trees, mangroves, savannah grasses, paddy fields and isolated villages: so much to see.

When he returned to Dem's village, the entire family gathered in front of the house waiting. They swore at him, enraged. Do you know what kind of problem you'll be in when a white man disappears from your house? Dem told him, Tomorrow we leave!

But, as if punishing him for being prodigal, Saliou journeyed home on the back of a donkey cart. He sat with goats for eight hours. The donkey staggered from the weight and was struck mercilessly by the rider. For months afterwards Saliou couldn't eat goat meat.

The marabou, contrary to the severity of his profession, was light-hearted, goofy, and charming with a gap-tooth. Customers came with varying requests: I want you to bring my son home for a visit— strike him with a sickness if that will make him return. I want you to make her fall in love with me. I want you to stop that person from hurting me— send the evil back to its sender. I'm going to Europe to sell drugs, and I want protection from law enforcement— if they stab or shoot me I want to remain unhurt.

When customers arrived he asked them to bring a candle, a thread, a bottle of soda, some bread, other food items. Those who brought food expected that by giving alms to homeless

men, their petitions would be favourable. For almost a year Saliou didn't have to worry about food.

Before eating, all the squatters would mutter some verses of the Quran to increase the potency of the charms. The marabou ordered them to intercede for his clients, specifying the needs and intended result.

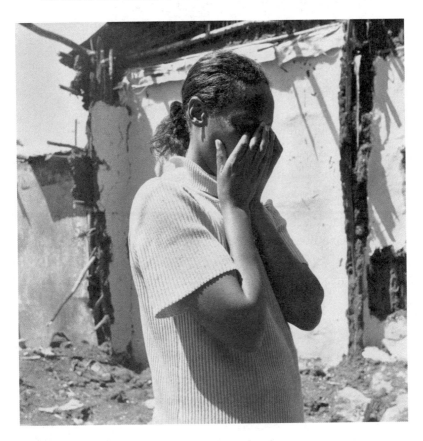

75

To an estranged lover, from Sinthian:

When night covered me in a prayer blanket
I interceded for our recumbent figures

And watched
the interminable horizon of lost love

I know you twice
first as azure distant beauty
second as marigold glistening body

They say those who leave die slowly
I say I dream much mourning

I dream you leaving.

On my way to Sinthian, in southeastern Senegal:
A man rode a donkey up a pedestrian bridge just out
of Dakar…

Sheep clustered behind a Hilux van at the pont à péage …

While a policeman inspected a bus at an intersection,
its back doors remained closed. But once he motioned it
forwards, the door opened suddenly, revealing passengers
sandwiched and hushed…

A dog, a boy, and a man: The man flagged down a car
and entered. The sullen dog looked at him, wagging its tail.
The car pulled away. At once the dog turned, then the boy,
headed home…

Two chatting girls near Fatick wore sleeveless jerseys, returning from netball practice. One held a ball under her armpit. Both drank from brown plastic cups. They walked like giantesses…

A little girl wearing a red blouse carried a baguette. The baguette was wrapped in a white shroud-like cloth, and seemed as long as her torso, even extending beyond her neck…

A man took a black ox for a walk beside farmland, rope tied to its leg…

A pregnant woman in a blue vest waited at the edge of the road, and smiled at a passing car…

A young woman sat behind a motorcycle, holding a cockerel and a broom in her lap, wearing a fluttering black scarf and blue jeans…

Mounds of unrefined salt in a region filled with salt lakes…

Two women exited the highway on wheelchairs. The woman in front needed no assistance; the woman behind was steered forwards by a little boy…

What makes me miss you so much? I admit it is, in part, the distance between your body and mine. Each body I saw on the road was mounting evidence that yours was far away.

All these weeks I will be alone and desolate in Sinthian. I will be seen as a stranger who comes to go. That does not devastate me as much as the fear that you love me no more. The women outside my room speak Pulaar, but it is your voice I hear. Come back to me.

In Sinthian, I spend a considerable amount of time observing trees. They are dense in the distance, sparse as I approach. Only when I am close enough do I notice their singularities. And yet, because I do not recognise any of them, they remain anonymous to me.

Trees are often named according to the places they frequently appear. A Kentucky coffee tree is a tree of central and eastern North America, a Brazilian pepper tree is to be found in Brazil, a Chinese scholar tree is deciduous and found in China and Japan. Etc. It must be, then, that the etymology of a tree is linked to the space it occupies. In this way, it possesses ancestry. Some trees will last a century, others five. But none will go down without a name. They are not named with words as they are with character. They allow a place to be given identity— for example the people in Sinthian often say, Let's meet under the neem tree, there's shade there!

In the city where you and I lived there were hardly any trees to serve as metaphor. Only now I am away do I realise that for you I must become a tree.

Every tree is the opposite of wandering.

Let me take shade under you, says one lover to another. If a tree supplies human lovers with language for comfort and consolation, it does so, without doubt, because of its scale. How does a tree manage to maintain its balance in the air? Dendrologists tell us that trees, as they evolve into upright plants, face the problem of gravity. Its aerial parts are pulled downward by wind and rain. So if it must survive, it must orient itself in relation to gravity. While new shoots grow up, new roots grow down. This geotropic response is a generalisation; sometimes shoots grow at an angle, or are vertical, and in trees with millions of roots, very few incline downwards. And yet, at the outset of its life, a tree's immediate concern is to solve its gravity problem, reaching at once for height and depth.

I remember sitting beside you in a Lagos restaurant, in the days when we still believed we would get married. I

avoided your eyes, although in fact you turned away from the table to ensure you didn't look at me. Lovers of our kind, those who had spent a year apart in long-distance affairs, are dissatisfied when they reunite for a brief moment. They want each other's endless devotion, but time is too short.

The analogy is tricky, but consider a love affair as a tree solving its gravity problem. How we might grow upwards, with continued affection for each other, yet at the same time remain rooted, although our lives are compromised by the intimate details we have of each other's flaws. The push of affection, the pull of knowledge. To stay in love we orient ourselves in relation to gravity.

I sit cross-legged in a busy vegetable market. Despite the irritating whirring of the houseflies, the man who inquires if I am American or Ghanaian, the women who mock the arrogance of their customers, and the chorus of several midday radio shows, I maintain my distraction, thinking of you.

In this village, the noise of running horses is of a different kind when the riders are little boys. The clatter of hooves is exuberant and carefree. This must be a great secret of nature revealed only to patient listeners. Now I share it with you.

The half-naked woman beside a hut, as dusk approached, held a pestle over her head. She brought it down and struck the mortar with a loud, thud! I looked at her dangling breasts, nervous. Then I walked on. The effect of that momentary stare was so powerful my fingers twitched— to relive the thrilling motions of fondling you.

I would return that night, and in my sleep find an indistinct bump beside me. Not a woman, not even a feeling: the idea of woman, the notion of feeling. As I turned in my sleep this bump turned too. A shard of light cut through the room, and I recognised my bump as a pillow I had cried on,

reached towards, curled around, prayed to. In those dire times, I could still imagine your body, distant as a foreign country, as place of return, again and always. How unsatisfactory, that metaphor. If the body might be compared to a foreign country, how much mileage might I cover to comprehend your receding frame?

Once I had a dream of being beheaded. The knife came to my throat at the exact moment I awoke. Disoriented, I welcomed the knowledge of my death. With that thought I fell into another dream. I was crouched at the corner of a room covered from floor to ceiling in marbles shaped like shards of rock. It seemed to be a final private moment leading to a public execution. I was aware of being in Sinthian, of having committed a grave offence punishable by a mob's justice. Then I woke again, and stood immediately from the bed, to avoid relapse into another pernicious dream.

Alas, my dreams are retrospective. How far in the past they go I can't tell— except I know they lead to you.

One afternoon Saliou teaches me how to ride a bicycle. Tense, I hold on to the handlebars and pedal. My movement and balance is only possible because Saliou steadies the bicycle from the rear. We are riding back and forth on a path that leads to, and away from, the centre of the village. All the villagers must have come to watch me. I do not know this as a fact, but as a possibility. I am watched by cheering children and men who call out instructions. When I am unaided by Saliou, the bicycle heads into surrounding bush. It is a miracle that I never fall off. At the beginning Saliou had said, Don't be afraid to fall.

The centre of the village is the intersection of four paths. A tree is at the epicentre of all the paths. Under this tree,

men recline until early evening on a wooden bed to play cards, stare in silence, and call out yamtham! Peace above all! And in response, Alhamdulillah!

I am here at the end of the raining season, when the villagers gather their final crop. As I approach Chief Kante's house I see in the clearing between the unpainted concrete houses maize seeds spread out in the sun.

When I arrive with Saliou, a boy is sent to buy tea leaves, and an old kettle with roasted peanuts is set in front of us. We eat and throw the shells on the ground. The boy, who is ten or eleven, heats the tea. The entire evening he sits over the kettle, making tea, and passing it to us in little glass cups. He fulfils this task with the temperance of a waiter and the muteness of a servant.

At the entrance to the compound where we sit, we attract attention. The Kante folk— daughters, wives, mothers, a toddling boy and girl, little sons— face us. Others who walk past say hello to test our knowledge of Pulaar. Walejem. Yamtham. Jaraama. Saliou speaks Wolof, and translates what they say to me. Each time they say Anglais it is in reference to me: What would a word in Wolof mean in English? Why does he speak only English?

I like the women. When we make eye contact they smile, as if to initiate silent conversation. We are wordless, but not at a loss. Our smiles are a compromise.

Mohammadu-Seydou, the little boy who sat at my feet picking peanuts now stands to get a toy. It's a car made from a plastic container, the kind used to store fluid for the engine of a locomotive. The car is led with a string. Mohammadu-Seydou brings blue and ash cars, one for a boy two years his senior. On the blue car *Messi-10* is incised. They run about the compound, but get bored soon enough.

In a little while one of the women has left us to go to the well. When I stand to help I can only draw water three times. My palms blister. The woman resumes her chore. The basins and cans are filled quickly.

We are invited to dinner. Seasoned balls of ground fish and mashed peanuts simmered in oil and were then boiled together with macaroni.

Before dinner Mariama Kante hennaed my fingers. She wet her fingers and covered mine with reddish-brown paste. Then she wrapped each dyed finger with strings torn from a plastic bag.

How long will the dye remain, I ask?

Until the nails grow out!

Why did I dye my fingers?

To see the way my fingers move as I write this to you.

I admit that in the terseness of my writing, my words might resemble a flickering light. In the nights we spent together, I looked forward to feeling your face against mine in darkness. Imagine how we were then: two recumbent figures known to themselves without the aid of light.

On the morning of my departure you woke before dawn to leave for work. I was half-awake, lying on the bed, watching you wear a dress in the dark. But I knew you were weeping.

Partir est mourir un peu. To leave is to die a little.

I now remember an image of my father. As a twenty-year-old he had stood in front of a school building holding a book, pictured in a deliberate sway. I know him in a way I will never know him in person— as young and fixated on the future. All that youth he carried in his smile and gaze is now past. Not only his past but also mine. I am young; all images of my youth will share this fate.

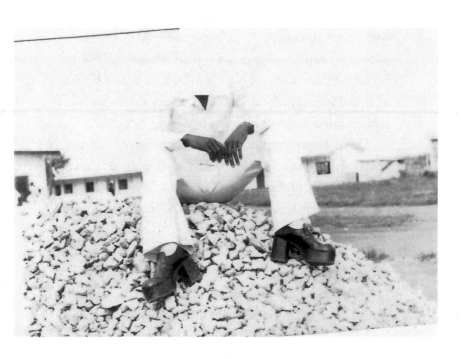

There, in Umuahia, on a rainy afternoon, a dead man was moved on a stretcher from hospital ward to morgue. I was sitting beside my father. The man was my father's age. I remember, as I looked at both men in a flash, what seemed like a similar serenity. One man breathless, his eyes closed. The other sitting in pain, no worry or pity in his eyes. The men who carried their dead nodded to me, bridging, if that were possible, the chasm between bereaved and comforter.

In the hospital, a fortnight earlier, my father had cried in pain, requesting water. Those who know these things say a man must not be given water in the moments after surgery, or else sure death. Yet my father was thirsty. Alone with him, my father's visitor approached with a bottle of water. He heard a sudden voice from behind. STOP! When he turned there was no one— it must have been the voice of God. He dropped the bottle and ran for the doctor, who told him he'd saved a man's life.

This is a story my mother told me. I believed her simply and in full. Despite her propensity to exaggerate, I know her truest sentiment was also mine. A corpse is the foremost expression of sedentary life. None of us had imagined my father unmoving.

My mother told me of my father crying when he saw the state of his house. For years he sent money from California to Afikpo to build it, on ancestral land. The house would plant his feet and my mother's feet where they belonged. But his friends had been reckless with his money, and the house amounted only to a pile of blocks, spread out in ungainly fashion. He cried, she said, bent over a cornerstone. In the years that followed he kept moving from place to place, Abuja to Lagos to Ile-Ife to Ohafia to Umuahia, shifting grounds known to an itinerant Presbyterian preacher.

If a dwelling could be permanent, it would be his soul.

In my family, though, a man's soul was once known as restless. My grandfather was pronounced dead more than once. Lying on a bed he returned time and again to the world of the living. After his first death he awoke to name his debtors. Who owed him a thousand naira, and who'd sold his goats without giving account. After his second death he came speaking of how he must be buried: No, they shouldn't worry my father much, but he must be given the burial due a man his age. There was a third, final death.

And then, what happens to an itinerant soul, one who does not dwell? There is hardly any way to tell. To dwell, in its subtle shifts of meaning in different languages, in High German, Saxon, old English, and Arabic, can suggest: to stay in peace, to be in peace, to reflect, to settle, to be still, to stop, his soul has stopped, pain had departed him.

Which is perhaps why Saba Innab, while in Marrakech, tells a story.

In 711-710, after landing on the coast overlooking the rock— later named as Jabal-ul Tariq, later corrupted to Gibraltar— its conqueror Ṭāriq ibn Ziyād ordered the burning of the ships that had brought the troops from Africa.

Humankind is perhaps uncertain about wanderlust; how to mitigate the growing temptation to move. The ships must be burnt.

77

For eleven days I live in a house that does not belong to my family, but to my father's oldest friend. I have come to Afikpo, my ancestral hometown, alone.

The town is noisier than I remember. In daily walks on Eke Market Road, I see people windmilling about, their gestures unrestrained, in the manner of city dwellers. I'd thought of Afikpo until now as a village, provincial. This is not the quiet I envisioned. And since it rains on the day of my arrival, the overcast sky is sewn on my mood like a badge.

My excuse for coming, I told my friends, was to meet my mother's family. My middle name is originally my maternal grandfather's. To question identity, I argued, you look in both agnatic and uterine directions. All I knew so far was how I descended from my father, based on conversation with him. But we'd discussed nothing of the matrilineal.

I am here at the end of many travels. I underestimate my exhaustion. I will meet my mother's family on another visit, I tell myself. The days unfold as if a lazy hand pulls open a window. I am bored. I cannot wait to leave.

I keep the curtains drawn. I recline on the bed. I read in low light. I call faraway friends on the phone for directionless organisation. I write a short story about a land dispute. And when I venture to the street, stirred by hunger, I meet a man who at once recognises my father's face on mine.

My name recalls the flashpoint of family tragedy, an uncle's disappearance during the Biafran War. "Emmanuel," a name my father didn't recall was my uncle's until my grandmother pointed it out to him, when they visited Afikpo the first December after my birth. In its literal meaning, the name affirms a presence. "God with us."

The last time they saw my uncle was in the final year of the war. He wore a bandage around his arm. He'd come in secret to tell them he was okay, would be okay, only a matter of time now, the end was in sight. No one would see him after that, or receive news of his death.

How could my father forget his brother bore my name? But he couldn't have. Remembering is not a mere act of will. In Afikpo, our names denote an unbroken link to the ancestors. The knowledge of the past is passed down in repressed retellings. My name is the fragment of a memory my father couldn't articulate at the moment of my birth. I am the one who returned, who returns. I am the recalcitrant returnee.

I seek my uncle's image. My father has told me there is a surviving photograph of him. I know there's a bookcase in the sitting room of the family house (at the entrance of which another uncle, who built it, had inscribed, "Because it is mine"). In previous trips, I went to the bookcase in search of the books my father read as an undergraduate, perusing with a boy's uncomprehending mind. On this visit the bookcase is nothing but a container for tattered books and papers, in an uninhabited room with broken shutters. The books I see, if their covers remain, are sullied with fingerprints. Or sometimes the pages are torn in two. I can tell these are not the traces of inquisitive hands, but of minds long disaffected. If as a boy I stared at the bookcase as a sacred reminder of my father's student days, the children of my relatives treat it as a curious plaything from the past.

Before pulling the bookcase open, I forget what the photograph is alleged to depict: My uncle standing with his malnourished siblings, his arm swathed in bandages? Or my uncle sitting on a pile of broken rock, his back to our town's only secondary school, wearing bell-bottom trousers?

I lift book after book seeking the photo album. What I perceived at the moment of entering the house becomes true. The album hasn't survived years of disregard. I fold my arms in silent rage. I look above the bookcase and see that even other photographs— of my uncle who built the house, my cousins as babies, and my grandparents in their rare couple photograph— have been taken away. Built with mud bricks in the 1970s, badly maintained, it survives in the 2000s as a dingy house. Any day now it might cave in, retaining its use through nostalgia, or family lore.

My uncle's photograph is unreachable. I do not know his face. As if, until I find him, what he looked like, my name remains suspect, and I a fake copy.

In my earliest recollection of Afikpo, I dance at a funeral. This memory originates from a video. I am seen beside my brother. It's dusty ground. Looking closely, I see the air around our feet spread in brown spirals. I notice our frenzied arrhythmic dancing. We have caught the attention of an encircling crowd. They smile at us, but around the edges of each smiling face, pity. As adults they know what we don't. Yet in their glance they tell us, even as I watch many years later, what we would come to know. A woman dear to us is being buried. Without a body, figments of memory.

As the video progresses, my father shepherds us towards the centre of the crowd. He's dancing too. He is increasingly expressive: his hands high, his body doubling, his head bumping. These are gestures of surrender; if stoicism could be illustrated in a dance it would be as his dancing body. He taunts grief. He is consumed by grief. He jigs as if realizing the finality of her death. Through dancing he is desperate to survive her.

I am in Afikpo again, now almost 20. It's the first time I'm shown her grave, which is a few yards from a narrow path, unmarked. It enrages me, her grave without inscription. The person who takes me there— a cousin?— points it out in a hushed tone, in a voice acknowledging in part the tragedy of her death, and the fact that we've all moved on. In that moment, I remain fixed to the spot, staring at her grave plastered with grey mud, beside a narrow path.

This proximity to the road, I realise as I write now, gives it a name. Every passerby will see the grave beside the road. Her memory is preserved in a stranger's glance.

Image Credits

The author and publisher gratefully acknowledge the permission granted to reproduce the photographs contained in this book.

Siaka Traore.
Untitled, 2016. (c) Siaka Traore, pgs. 8, 14, 39, 82, 137.

Tom Saater.
Untitled, 2014. (c) Tom Saater, pg. 25.

Dawit L. Petros.
Confrontation (The always incomplete construction of thresholds), Tangier, Morocco, from the series *The Stranger's Notebook*, 2016. (c) Dawit L. Petros, pg. 28.
Reorientation, 2014. (c) Dawit L. Petros, pg. 116.
Untitled, Tangier, Morocco, from the series *The Stranger's Notebook*, 2016. (c) Dawit L. Petros, pg. 118.
Untitled (Prologue), Yamoussoukro, Côte d'Ivoire, from the series *The Stranger's Notebook*, 2016. (c) Dawit L. Petros, pg. 128.
Tra il dire e il fare c'è in mezzo il mare, Lampedusa, Italy, from the series *The Stranger's Notebook*, 2016. (c) Dawit L. Petros, pg. 158.
Act of Recovery (Part II), Nouakchott, Mauritania, from the series *The Stranger's Notebook*, 2016. (c) Dawit L. Petros, pg. 161.
Untitled (Prologue III), Nouakchott, Mauritania, from the series *The Stranger's Notebook*, 2016. (c) Dawit L. Petros, pg. 163.

Abraham Oghobase.
From the series *Are We Humans*, 2010. (c) Abraham Oghobase, pgs. 31, 44, 150.

Jide Odukoya.
Daniel, from the series *Nigerians in Libreville*, 2012. (c) Jide Odukoya, pg. 35.

Photographer unknown.
From author's family archive, pgs. 41, 197.

Emeka Okereke & Emmanuel Iduma.
From the series *A Walk in a Daraa*, 2014. Courtesy of Invisible Borders Trans-African Road Trip 2014: Lagos – Sarajevo.
(c) Emeka Okereke/Emmanuel Iduma, pgs. 46, 54, 56, 74, 78, 92, 114.

Acknowledgements

This book is an imaginative gesture, proffered to the many lives that entered mine— no mind that its raw material came from actual trips in African countries. The "we" I often refer to was a rotating group of photographers, visual artists, and writers I travelled with, courtesy of Invisible Borders Trans-African Photographers' Organization. On other occasions I travelled alone. Between those facts and what is recorded here— in the twilight worlds between experience and memory, fiction and criticism— I can only hope I have left a space large and conceited enough for the reader to inhabit.

Parts of this book appeared in a number of publications, in similar or different forms, including: *Lives That Enter Mine* (2016), a chapbook published by Invisible Borders; *The Africans* (2016), edited by Omar Berrada, following a solo exhibition by M'barek Bouhchichi; and "The Sum of Encounters," a travelogue essay for Carnegie International, 2018.

I extend unreserved gratitude to a large cast of friends and colleagues for their support, professional and otherwise:

Bibi Bakare-Yusuf, for her help with unfurnished drafts, and for sharing this book with a wider audience; the inimitable Emma Shercliff, and the rest of the Cassava Republic team; David Levi Strauss, for placing my foot in the door, and championing my work; Annette Wehrhahn, without whom my time at the School of Visual Arts would be insufferable; Claudia La Rocco, Jennifer Krasinski, and Tatiane Schilaro, early readers of this mongrel book; Emeka Okereke, for the years of professional tutelage with Invisible Borders, and for early support; Ayobami Adebayo, Dami Ajayi, Nengi Omuku, and Zahrah Nesbitt-Ahmed, for keeping faith with the ebbs of

my life; Adebiyi Olusolape, Billie McTernan, Ndinda Kioko and Wunika Mukan, dear friends who remain with me, in and out of place; my big brothers Dawit L. Petros, Frankie Edozien, Shaun Randol, Teju Cole, and Victor Ehikhamenor; Robert Bergman and Laurie McConnell, beloved comrades; my auntie Sokari Ekine; friends and adopted family who made, and now make, New York City a kind of home—Amitava Kumar, Donald Molosi, Ebuka Uyanwa, Elka Krajewska, Esther Oradiakumo, Irene Nwoye, Josh Begley, Kelechi Okere, Maaza Mengiste, Mona Eltahawy, Oluremi Onabanjo, Princess Ikatekit, Tamerra Griffin, the Riskins (Julie, Robin, and Steve), Seun Aladese, Thanu Yakupitiyage, and Wendy Magoronga.

For their invaluable help when I was a stranger in their cities: Eric Gottesman, George Bajiala, Ingrid Schaffner, Mamadou Diallo, Maud Houssais, and Moussa Sene.

As always, my siblings.

I express solidarity with the following institutions where this book was developed: L'Appartement 22 and Kulte Gallery in Rabat, Thread Cultural Center in Sinthian, Danspace Project in New York, Kimmel Harding Nelson Center for the Arts in Nebraska City, Jentel in Wyoming, Carnegie Museum in Pittsburgh, Ledig House in New York, and the MFA Art Writing Program at the School of Visual Arts, New York.

In memory of Veronica.

And for my parents, Francis and Sarah Iduma.

Transforming a manuscript into the book you are now reading is a team effort. Cassava Republic Press would like to thank everyone who helped in the production of *A Stranger's Pose*:

Editorial
Bibi Bakare-Yusuf
Layla Mohamed

Design & Production
Michael Salu
Akeem Ibrahim &
Allan Milton Castillo Rivas

Sales & Marketing
Emma Shercliff
Kofo Okunola

Publicity
Emeka Nwankwo
Lynette Lisk